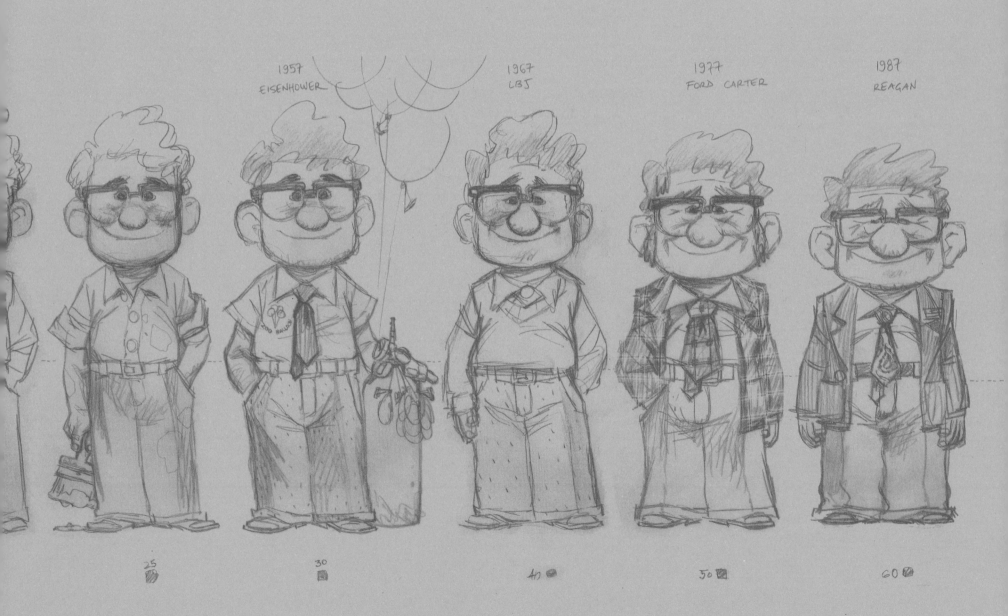

1957
EISENHOWER

1967
LBJ

1977
FORD CARTER

1987
REAGAN

2000 BALLS

25

30

40

50

60

THE ART OF UP

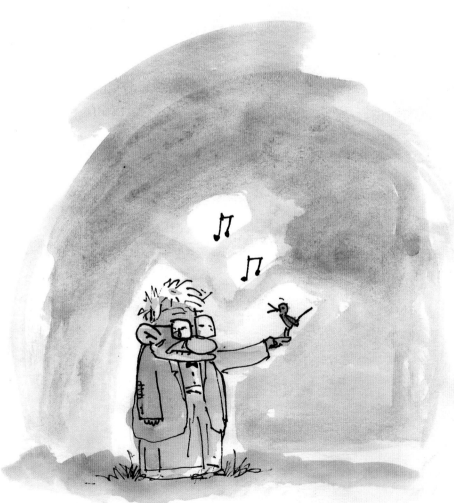

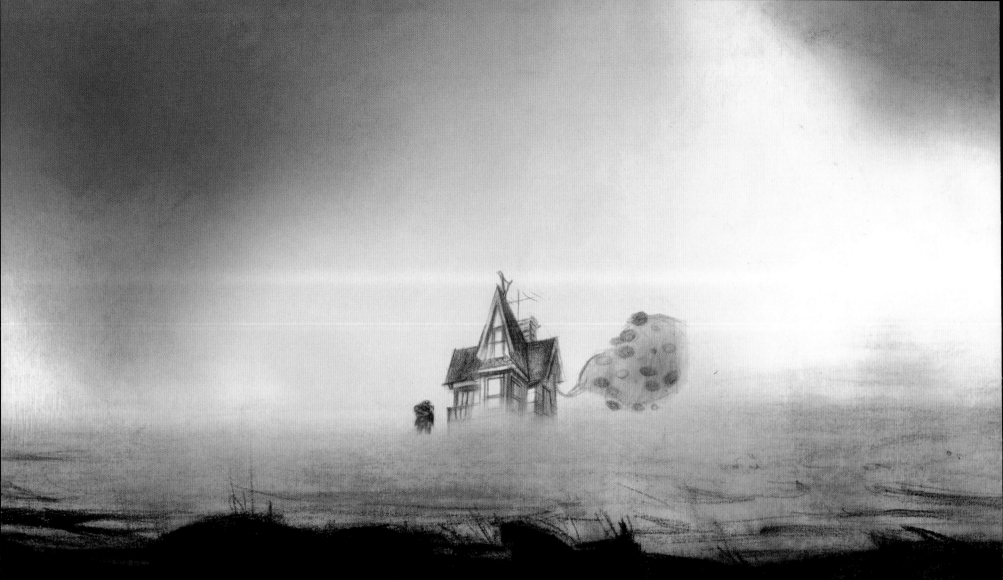

THE ART OF

Disney · PIXAR

UP

By Tim Hauser
Foreword by Pete Docter

CHRONICLE BOOKS
SAN FRANCISCO

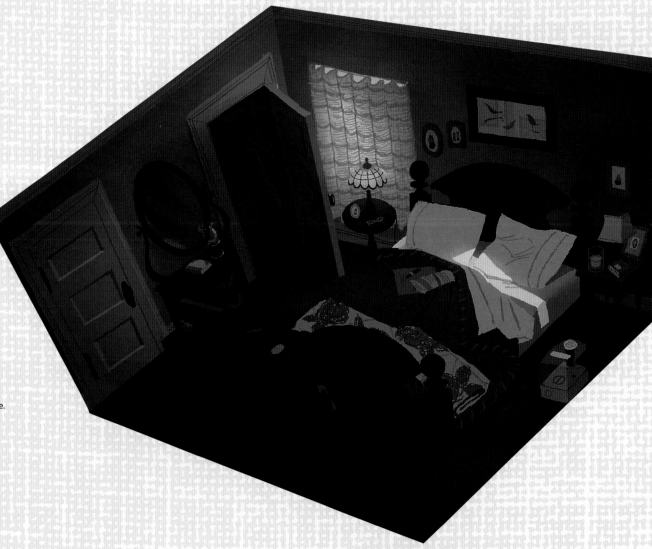

Library of Congress Cataloging-in-Publication Data available.

ISBN: 978-0-8118-6602-6

Manufactured in China.

Designed by Glen Nakasako, Smog Design, Inc.

10 9 8 7 6 5

Chronicle Books LLC
680 Second Street
San Francisco, California 94107
www.chroniclebooks.com

(Page 1) **PATRICK MCDONNELL** | watercolor | 2005
(Page 2–3) **DANIEL ARRIAGA** | pencil | 2007
(This page) **DANIEL ARRIAGA** | digital | 2007

Contents

FOREWORD

RICKY NIERVA | gouache | 2004

*U*P BEGAN WITH THE THOUGHT OF ESCAPE. There's a reason most animators became animators: We're socially challenged. We were the last ones picked for the baseball team, the pasty, awkward kids who sat off by themselves and didn't talk to others. For me, it was a lot easier to draw someone than to talk with them.

I like to think I've gotten better at it as I've grown, but more often than I care to admit, the world is still too much. Too many meetings. High-pressure social situations. People everywhere! I find myself plotting how to get marooned on a desert island. I start to understand why folks grow beards, build shanties in the forest, and write crazed manifestos on how paper clips lead to the downfall of humanity.

Okay, I don't actually understand the beard part. But "getting away from it all"? Sign me up.

As it turned out, I wasn't the only one who felt this way. Bob Peterson and I got to talking about it one afternoon. And as tends to happen around here, this talk led to an idea for a movie. It became the story of Carl Fredricksen and his floating house.

Odd as it was, the image of a floating house captured that feeling of escaping the world. At the same time, developing a new film meant that Bob and I got to mimic Carl: We'd sit at our desks, squirreled away from the hustle and bustle of the other films in production, to write and draw.

There were times when we thought to ourselves, "An old man in a floating house? With a Wilderness Explorer and a talking dog? What are we thinking? Who's going to connect with this?" One look through this book and you'll find that Bob and I weren't the only ones who did.

Four years later, more than 300 of us are floating along in our studio-sized house, making this movie. And although from time to time I still long to escape from it all, I'm so happy to have had the chance to work with these amazing people. As Carl discovers, it's the people you're with who make the adventure worthwhile. I wish you could all be as lucky as I was to know them. At least you'll get to meet them though their art—which is probably more than you would if we were all on the same baseball team.

— *Pete Docter*

ALBERT LOZANO | marker | 2008

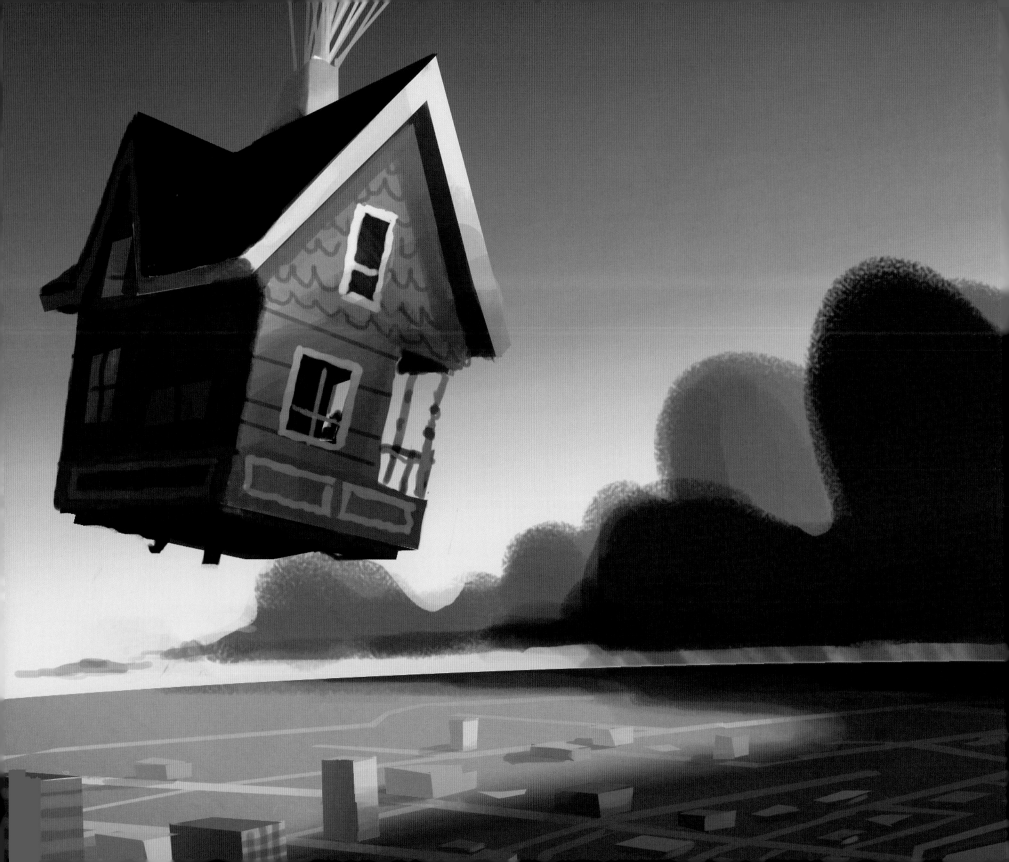

Introduction

FLIGHTS OF FANTASY

> "Fantasy, if it's really convincing, can't become dated for the simple reason that it represents a flight into a dimension that lies beyond the reach of time."
>
> — *Walt Disney*

FROM ALICE TO DOROTHY GALE, FROM Wendy Darling to Harry Potter, the dreamers of modern imagination are, more often than not, children. Their fantastic journeys are a symbolic rite of passage, taking them from callow youth to responsible adult.

But why should kids have all the fun?

Meet balloonist Carl Fredricksen, the atypical senior citizen who courageously floats up, up, and away into the azure skies of his own unrealized ambitions.

Carl's journey begins in his childhood in the 1930s. He and his friend Ellie, inspired by their hero, explorer Charles Muntz, dream of soaring with Muntz to the wilds of South America, far away from their quiet Midwestern lives.

Sadly, though, dreams have a way of eluding our grasp, as adulthood, marriage, work, and the other realities of life intervene. Still, Carl and Ellie keep their hopes of adventure alive, even as they are married and time slips away. But when Ellie dies many years later, Carl is lost without his treasured wife. To make matters worse, their home is threatened by encroaching development.

"When the world threatens to take Carl's house—his last connection to his wife—Carl does what any normal seventy-eight-year-old man would do," says *Up* codirector and writer Bob Peterson. "He ties thousands of balloons to his roof and floats the house into the sky, to fulfill the promise he made many years ago. He's going to bring Ellie, at least in spirit, to Paradise Falls, far away in the South American rain forest. This is his last chance to give her that big adventure they never had in life."

Carl rigs the house so he can steer with his weather vane, points it south, and takes off. Before long, he discovers a stowaway. Russell is an eight-year-old Wilderness Explorer who has all of his badges except one, "Assisting the Elderly." The boy has been stalking Carl for weeks, trying to mow Carl's lawn or rake his leaves, with no luck. Now that he's along for the ride, the boy is determined to assist Carl whether the old man likes it or not.

Carl and Russell make it to South America, but they crash short of their goal, so now they must hike the fifteen miles to Paradise Falls, towing the house like a giant Macy's Parade balloon. But before they can get there, a shadow of the past intervenes. Will Carl choose to move forward with his new friend or become hopelessly stuck in his dreams of days gone by?

"We like to call this a 'coming of old age' story," quips Peterson. "The true adventure of life is often found in the mundane and the relationships between us all. It's not 'out there'—it's right here and now."

Despite the advanced years of the protagonist, creator Pete Docter finds that audiences of all ages can relate to Carl's journey: "Maybe we haven't been to South America or to Australia or whatever life's dream we've had. But if we have friends, a family, that's what life is all about. A sense of appreciation."

Unlike Lewis Carroll's afternoon of spontaneous invention, Pixar's visit to Wonderland was not conceived on a lazy drift downstream. The story of *Up*'s creation was a bit of an odyssey of its own.

"After *Monsters, Inc.*, I started developing a couple of projects," Docter recalls. "Bob and I were working on an idea that was rather abstract. It was about these two brothers who lived in a mythical, Muppet-like world—a floating city. There were a lot of elements in it that we loved and people responded well to the idea, but the story wasn't really clicking. The emotional foundation was not solid. We took a step back and realized that the most intriguing thing about this floating city was the appeal of isolation, like when you've had enough of people and want to go live on a desert island by yourself."

Realizing further that a floating city was hardly isolated but was instead composed of an entire community, Docter allowed his escapist inclination to evolve. The focus of the story shifted to the single occupant of a lone, flying house.

"The story had simple beginnings, in thoughts like, 'We get a kick out of old people. Is there anything fun we can do with an old person?'" says Peterson. "Pete had drawn a cranky old man selling

the happiest balloons you'd ever seen. There was something to that contrast. The story just started building from there."

Early in the process, the filmmakers embraced Peterson and Docter's premise of an aging man trying to hold on to his dreams. They were clearly touched by the emotional tale of a relationship passing. Producers responded in kind. Peterson's story pitch was so successful that, even when it was presented with very little visual support, listeners had strong emotional reactions. They felt an immediate connection with Carl and a driving desire to see him succeed, because there was so much empathy for his immeasurable loss: that great romance he had shared with Ellie.

4·5·09

The directive from the top? *Up* was to be the studio's most emotive film to date. Docter had his green light. "Pixar wanted a film that came from our hearts, so they let us run with it."

In Carl's story arc, he needed to accept Ellie's death in order to find his own way forward. But with all his instincts telling him to hang on to what he knew, how would Carl find that brave new world with his eyes so firmly fixed on the rearview mirror?

The *Up* story team, led by Ronnie del Carmen, drew from life experiences to build the emotional foundation for an "unfinished love story." "What Carl wants to do is complete a promise to his wife that they would visit Paradise Falls together," says del Carmen. "He was married to this exuberant, adventurous girl. Because Carl had led a very simple life, he felt that he had not fulfilled her hopes and dreams. She died before he could. So he has this guilt throughout the journey, thinking, 'All I want to do is fulfill this wish for Ellie. I missed this.'"

"There is a strong moment when Carl's wife gives him absolution, a reminder that 'the life that we lived together was a grand adventure—and I was not wanting for more. *You* are my greatest adventure.' I love that. In the union between two people, life is an adventure worth taking wherever it ends."

With the little house as Ellie's avatar, Carl embarks on a quixotic quest to soothe his aching heart. What he unexpectedly finds is that this

12

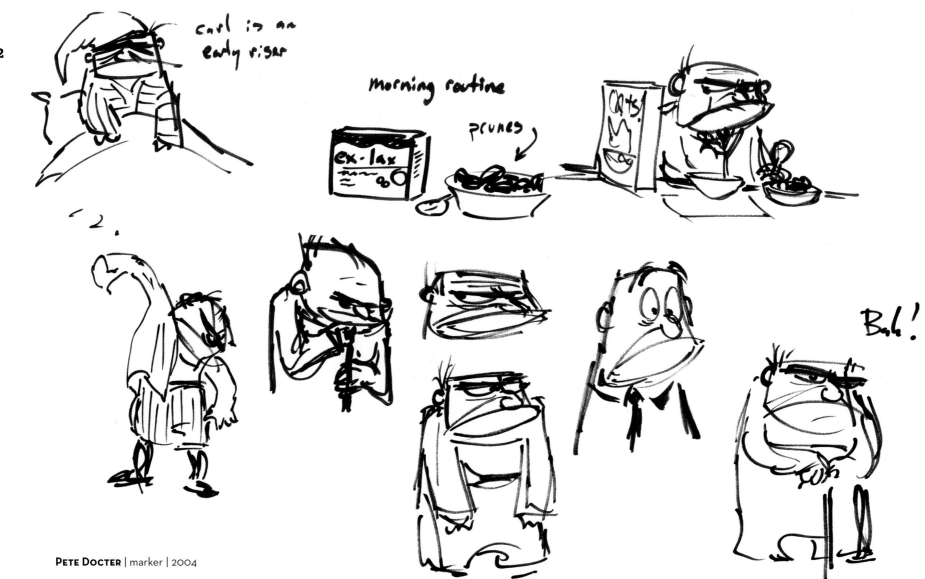

carl is an early riser

Morning routine

ex-lax

prunes

Oats

Bah!

PETE DOCTER | marker | 2004

Pete 6.04

lifetime of love was already more rewarding than any lofty adventure. Maybe he hasn't reached the end of the road just yet—as long as there are other people to care about.

Visual storyteller Docter plays out Carl's change in action: "Carl, in the end, throws all the stuff out of his house, realizing, 'I've been trying to achieve something that, ultimately, I didn't need to. I didn't have to do it for Ellie. I don't have to do it for myself.' But he would never have learned this had he not undertaken the journey."

A proper epic journey requires colorful characters to accompany the hero on his quest for fulfillment. Carl comes to find out that there are others around him who are also engaged in misguided pursuits. Russell is on a quest to attract his father back into his life, while Dug, the gentle-natured dog, is out to prove his worth in the vicious Alpha Pack.

In this unlikely amalgam of travelers we find context, conflict, and laughs. The dogs Carl encounters when he lands in South America wear telepathic speaker collars that allow us to hear their very literal thoughts, providing refreshing humor in the midst of emotional upheaval.

"Your dog doesn't really think all of those complex thoughts, but it seems like it does," grins supervising animator Scott Clark. "But humans do understand dog behavior on a subconscious level. So when we match those recognizable dog behaviors to a human voice, people get a kick out of recognizing their own pets in the animation."

"I love comedy. I'm always looking for ways to bring humor into the movie," Peterson agrees. The talking dogs evolved early in story development. But as the emotional elements arose in the film, the storytellers felt they had to keep those elements in check so the lighter sequences wouldn't become too silly by contrast. At the same time, Carl's antagonists are never mere comic relief. Peterson finds in them, especially Russell, an entertaining way to connect audiences to the heart of the matter: "Russell was born out of the hope that we could pair Carl with someone who had a bit of the same wisdom that his wife had, a little bit of that joie de vivre."

"*Up* is about letting go of the past, letting go of the guilt over missed opportunities," story artist Enrico Casarosa agrees. "By freeing himself of this self-inflicted cage [of guilt], Carl is able to be alive again, be present, and connect to persons around him like Russell."

For Docter, this relationship becomes the key with which audiences can get into the story of unfinished business. "The relationship potential for Carl grabbed everybody. He and this kid both have big holes in their lives that they are not conscious of. They need to fill that gap for each other. This is not just a comedy or a buddy picture. It's a love story," he adds. "We set up a real emotional foundation on which all this wacky stuff happens. I don't think the story has any meaning or weight unless you have that emotional background."

Indeed, part of any fantasy filmmaker's challenge is to relate the ephemeral and symbolic nature of dreams in a sympathetic, grounded way. Viewers want something they can grasp. Audiences are subconsciously searching for a direct, emotional, personal connection to dreamlike material. So how does the filmmaker develop that connection for an audience?

After a string of successes with heartfelt fairy tales and fables, Walt Disney famously struggled in the story room while bringing more intricate literary fantasies like *Alice in Wonderland* and *Peter Pan* to the screen. "Charlie (Chaplin) taught me that in the best comedy you've got to feel sorry for your main character. Before you laugh with him, you have to shed a tear for him. That was the trouble with our *Alice in Wonderland*," Disney later recalled. "Lewis Carroll's Alice wasn't a sympathetic character. She was a prim, prissy girl who bumped into a lot of weird nonsense figures. . . . If I can't find a theme, I can't make a film anyone else will feel," he decided.

Writer Noel Langley successfully argued the same points to MGM producers Mervyn LeRoy and Arthur Freed as he adapted *The Wizard of Oz* for the screen: "You cannot put fantastic people in strange places in front of an audience unless they have seen them as human beings first."

Such wisdom was not lost on Pixar's production team. The filmmakers' passion for *Up* comes from its meaning. And there are many rich messages flowing through the story's subtext, including philosophies of a distinctly Eastern flavor. Producer Jonas Rivera shares a key point that seems to echo the Zen philosophy of mindfulness: "Carl's arc is that he struggles to hold on to the past but learns to live in the present."

Del Carmen's story work delves deeper into that theme. "We never focus on where we are until it's too late. The journey that we undertake trying to reach a goal ends up being more important than the goal itself. It seems to be a universal aspect of everyone's life. When we're younger we don't have enough wisdom or experience to appreciate that."

"This is a story about what is important in life, and how do you simplify that? Get rid of all those other things that are just noise," says Docter. "When you get older and have kids, you realize, 'I'm not going to be here forever. Do I really need a new widescreen TV and a car? What am I going to look back on and remember in my dying days?' As Bob wrote in an early draft of the script, 'I think it's the boring stuff that I remember the most.' It's those little moments that resonate."

"Was it intentional?" Rivera raises an eyebrow at the suggestion of a consistent philosophy at work in *Up*. "I can't tell you that we were sitting in the story room trying to plug in the right amount of appropriate Eastern philosophy. I think it was organic."

Peterson agrees that the film's minimalist point of view reflects the filmmakers' natural process in their search for a streamlined story. "That comes out of defining what is most important. When you discover that, a lot of things fall away."

A spirit of mindful calm informs the dramatic structure, the pace, and the art of *Up*. This lyrical tone is due in part to the influence of anime, an aesthetic seen in the film fantasies of Japanese director Hayao Miyazaki (*Spirited Away*, *Princess Mononoke*, *My Neighbor Totoro*), long admired by the Emeryville crew.

"What I love most is Miyazaki's connection with nature and the human condition," shares designer Daniel López Muñoz.

"Miyazaki's films evoke a magical element, a suspension of disbelief," adds directing animator Mike Ventorini. "He's able to create a world that couldn't possibly exist, yet you believe in it 100 percent. *Up* has that same 'fairy-tale' quality."

Eclectic flights of fancy may evoke skepticism in practical thinkers. But when fantasy flourishes on its own terms, the symbolism reaches deep into our imagination, allowing us to step into the role of the protagonist, to escape the safety and security of the familiar, to explore realms of allegory and allusion.

Daring to dream can be a lot of fun. It takes us upward and outward to the unknown. The same could be said of Pixar's creative process. "We start with unusual premises. We go down a path where we're initially a little scared because we're doing something brand-new. It's challenging, but out of that challenge comes the new and the interesting," offers president Ed Catmull.

"Pete [Docter] and I worked together on *Monsters, Inc.*," recalls Peterson. "Monstropolis was a unique new world that audiences had never experienced. Our hope was to bring a bit of that feeling to the world of Carls' journey. We wanted it to be unexpected. That's one reason I like working with Pete Docter: Creating new worlds is his wonderful specialty."

Time and again, Pixar creatives have raised the bar for what can work on the animated screen. But, just like the fantasy filmmakers of the past, they've found that their biggest challenge is in making the unreal seem natural and logical to audiences—to convey what Walt Disney liked to call "the plausible impossible."

"The hardest part of creating the art for this film was to make something that's so unbelievable in real life seem believable on the screen," says production designer Ricky Nierva. "We are constantly being challenged as artists, but this is why we create films. We want to create believable worlds.

We want to tell stories. And we want to make the artwork, the look of the film, support that story."

Pixar's chief creative officer, John Lasseter, lays out his rules for relatability. "In order to do a successful animated film, you have to do three things: You have to tell a really compelling story that keeps people on the edge of their seat. You have to populate that story with memorable, appealing characters. And you have to put the story and those characters into a believable world— not a realistic world, but a believable world."

Audiences want to be pleasantly surprised, but they also want to be assured that all roads will lead somewhere familiar and specific. Pete Docter has the trip completely mapped out. "Even though our story is set in a fantastic, otherworldly place, it is built on a foundation of relatable emotion. We've worked very hard to set up the relationship that is driving that whole journey. We knew, diving in, that we had a film where the audience must believe that a guy can float his house into the sky with balloons, which, of course, is absurdly impossible—but you will accept it in animation because we've created a world in which that seems plausible."

PETE DOCTER | marker | 2004

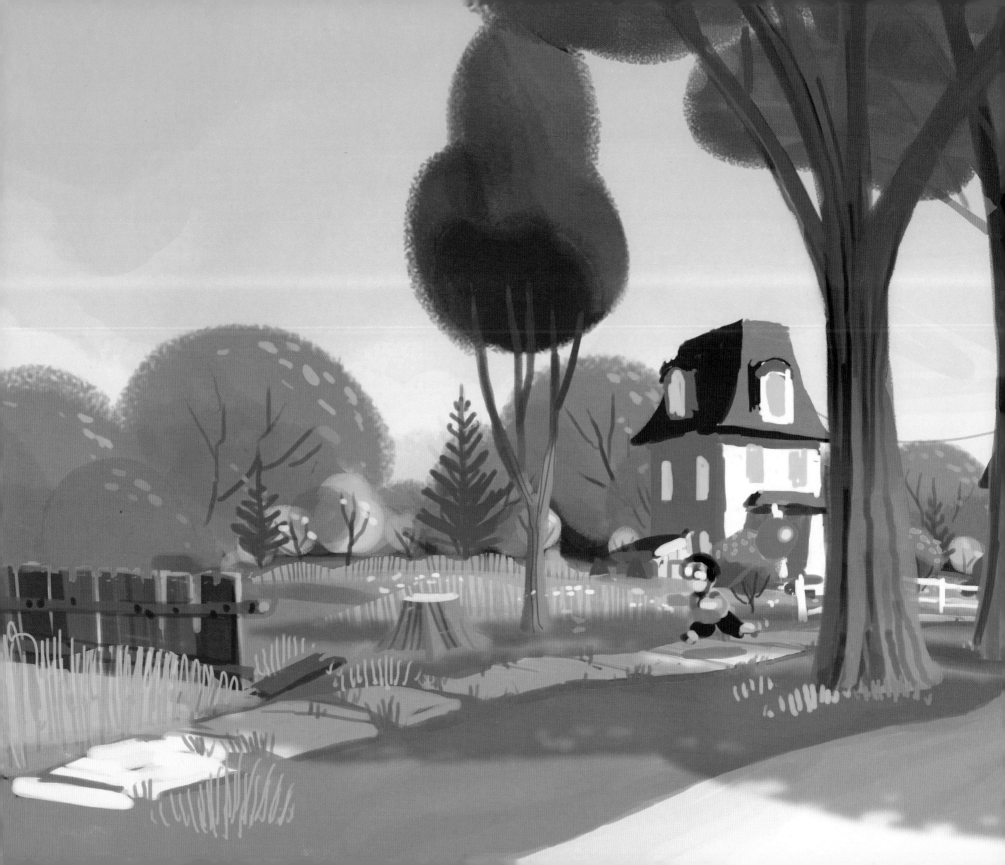

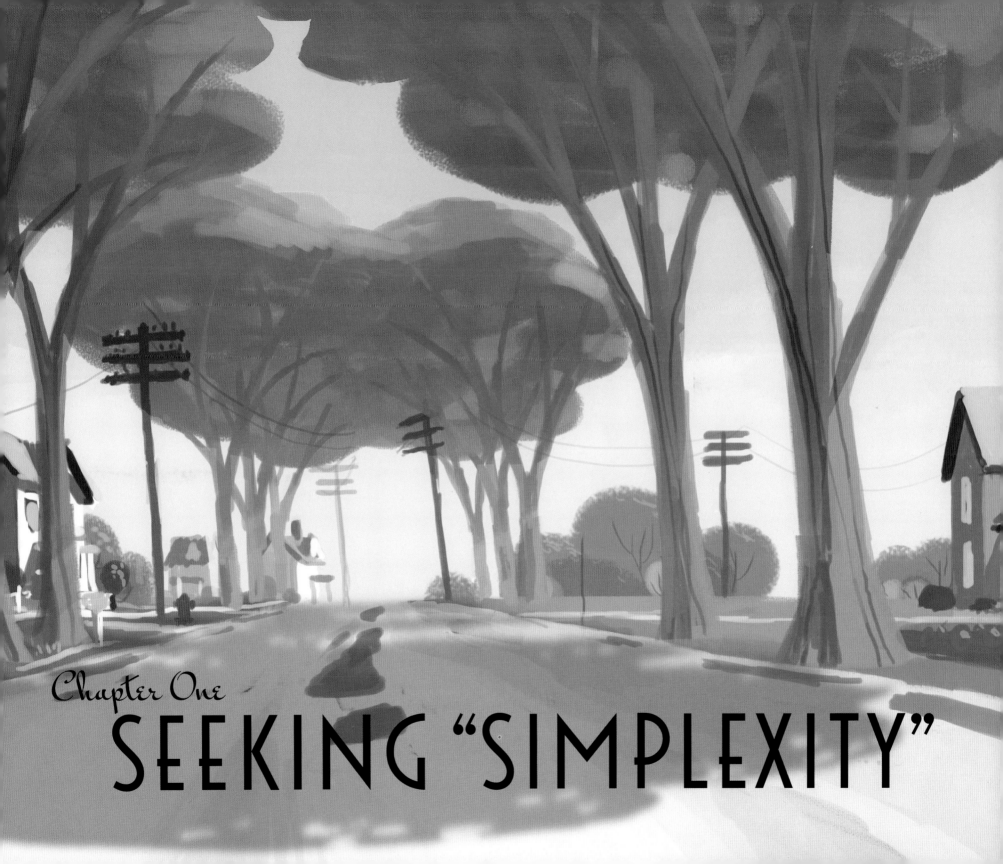

Chapter One
SEEKING "SIMPLEXITY"

> "Simple is good."
> — *Jim Henson*

"THE TERM WE CAME UP WITH WAS 'simplexity,'" explains production designer Ricky Nierva. "That is the art of simplifying an image down to its essence. But the complexity that you layer on top of it—in texture, design, or detail—is masked by how simple the form is. 'Simplexity' is about selective detail."

Up's designers wanted to push the envelope to see how far they could go in expressing the essence of a figure or setting—creating a caricature where the key elements are highlighted—while still retaining believability. Their intent was to do this without becoming so abstract as to alienate the audience. In a way, "simplexity" is midcentury modernism reinvented for computer graphics—and the creators of *Up* couldn't be more pleased about the shape of things to come.

"We chose to caricature and heighten the sense of shape. We missed that sort of abstraction in animation," says Pete Docter. His passion for cartoon modernism, an approach more often passed over of late in favor of increased realism, is shared by much of the animation community. Earlier graphic artists set the style for the golden age of animated films, storybook illustration, advertising art, and comics, from the expressive two-dimensional drawings by Walt Disney's "Nine Old Men" to the "limited animation" stylings of the United Productions of America (UPA) studio or the comic strips of Charles Schulz and Charles Addams. Such simplicity of shape, line, and form defined our notion of the cartoon medium and, later, the pop art movement embodied by the work of Warhol and Lichtenstein.

For inspiration, Docter looked to a caricature artist whose work has graced many a Broadway and Hollywood poster. "Al Hirschfeld was brilliant in his ability to distill a caricature down to just a very few number of lines, yet there is so much more there. Not only in terms of light and shadow, but detail and personality. You see these drawings that are dripping with rich character."

(This page) **RICKY NIERVA** | marker | 2005
(Previous spread) **NAT McLAUGHLIN** | digital | 2007

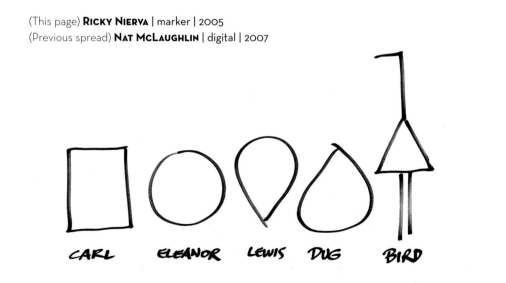

CARL ELEANOR LEWIS DUG BIRD

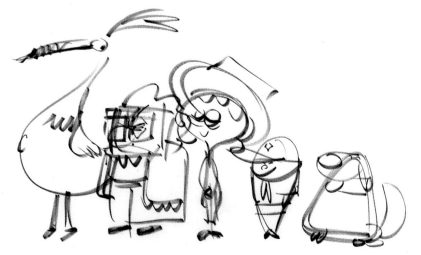

Following this tradition, Pixar's artists purposefully designed the characters in *Up* to be stylized and graphic, in order to convey the idea that theirs was a world in which fantasy could happen. "This is a story about a man who flies his house away with balloons. So there needed to be a certain amount of whimsy, a certain amount of 'once-upon-a-time' feeling to the design," offers Jonas Rivera.

"What's neat about the stylization is that it came out of Pete's vision for the story and the simplicity that he'd been going for from the beginning," adds Daniel López Muñoz. "It's not that this was a simple story by any means. It dealt with a lot of complex real-life feelings. But Pete wanted to express the essence—take away all the noise to leave you with just the heartfelt issues."

The secret to simplexity is that every shape is a symbol. The circle represents the future; the square symbolizes the past. The square and circle motifs visually connect us to the simplicity of the story and allow the details to fall away, so the eye, and the mind, are not caught up in the clutter. Bob Peterson illustrates how that thematic choice was developed in the cast: "Most of the dynamic characters surrounding Carl—Dug, Russell, the Bird, and Ellie—have curves. They are sort of rolling, off-balance, moving forward. Then here comes Carl, least likely to change. He's the square that all of those circles have to push so that he can actually start making changes."

This conceit of employing basic shapes as opposing factions has many precedents, including Walt Disney's abandoned project *The Square World* (previewed in a 1944 storybook entitled *Surprise Package*) and the 1971 animated version of Harry Nilsson's rock fable, *The Point!* And the idea has fascinated Pete Docter for decades. Albert Lozano remembers that the notion may have first taken shape when Docter was an animation student at California Institute of the Arts: "Pete's CalArts film, *Next Door*, was also about a circle and a square. This little girl who is a circle is playing the kazoo with an old man, who is a square, and they become friends. So *Up* is essentially a big-budget version of that same idea."

No matter what its origins are, the very specific production styling of *Up* requires its own unique fusion of form and substance. "We looked at everything from *The Muppets* to old Japanese cartoons for inspiration," says animator Shawn Krause. "We wanted to take this very simplified idea of the circle and the square and pull back the animation, trying to keep the animation very stylized, very simple."

Sculptor Greg Dykstra finds that the film's brevity makes stylization a necessity for efficient storytelling. "We have so little time in film to tell a character's story that you need as much help as possible from the visual cues, so that when an audience sees the character for the first time, they already get a feeling of the personality. That means that less will need to be communicated through dialogue."

In the streamlined stylization of Rankin/Bass stop-motion films of the 1960s, or even *The Muppets*, the visuals and communication in *Up* are more direct. Design is simplified to the essence of the characters. "We almost thought of Carl as a Muppet in that 'less is more.' The style is super simple, but it reads instantly," says supervising animator Scott Clark.

The late Jim Henson felt much the same way about the simplicity of his Muppet creations. "You're assisting the audience to understand; you're giving them a bridge or an access. And if you don't give them that, if you keep it more abstract, it's almost more pure," said Henson.

But here's where the simplicity ends and the complexity begins.

Not only are the characters and environments of *Up* inspired by *minimalism*, but the team also drew inspiration from *miniatures*, a couple of misfit aesthetics in the world of computer graphics.

"We were inspired by the stop-motion animation from Rankin/Bass. Our world is supposed to feel miniature in that same way," says character supervisor Thomas Jordan. "Especially for Carl's house we wanted that cozy, small, contained feel that stop-motion gives you," comments Docter. Like most children of the TV generation, *Up*'s creators hold a special place in their hearts for the

evergreen "Animagic" holiday specials produced by Rankin/Bass in the 1960s and 1970s (such as *Rudolph, the Red-Nosed Reindeer*; *Mad Monster Party*; *The Little Drummer Boy*; and *Santa Claus Is Comin' to Town*). These charming stop-motion programs, animated in Japan, have continued to inspire contemporary model makers, such as Tim Burton with *The Nightmare Before Christmas* and *The Corpse Bride*.

Why not bring that handcrafted world of stylized sets and fuzzy trimmed fabrics to the computer screen, asked the team at Pixar. It seemed simple enough. Well, it turns out that duplicating tiny tabletop materials digitally is anything but an automatic function.

"How do you get something to feel handmade in the computer? The computer creates a geometric perfection, but that handmade quality is about imperfection," observes Ricky Nierva. His solution was to exaggerate those imperfections, to make them oversized. The strands of hair, the eyelids, feathers, fingernails—are thicker, larger, as if made by hand for stop motion.

Nierva coined another word for that effect: "chunkification." "When you scale down an object for a diorama or a doll's house, you take away detail. The textures are exaggerated, blown up, or 'chunkified,' as on a doll's clothes or the trim on a stop-motion puppet. Patterns become bigger and thicker, creating a charming, toylike quality."

As Nierva suggests, a lot of happy accidents occur when stop-motion animators build miniature sets and puppets out of full-size physical materials. Textures, patterns, and even flaws come forward naturally in the process. It's not surprising, then, that building that happenstance handmade quality into a computer model requires delicate planning.

"There is a certain point where the fabric textures, if you blow the scale up too far, start to feel like a potato sack, like burlap," says shading art director Bryn Imagire. "So we had to push [the design] to the limit and then bring it back again so that it felt right. But that can be really fun. You get to be a lot more creative about how things are done. It's not the real scale of things, but you can tell when it's wrong, too."

Relative scale also became a challenge for the crew when an object was exaggerated. As the sparse detail was enlarged, everything else on screen looked small by comparison. That wouldn't do when a prop or setting was supposed to appear large or vast.

"The miniature directive worked great for certain things, like the house, but for Muntz's dirigible or things that were supposed to look big, it actually hindered the effect," explains veteran Pixar production designer Harley Jessup. "We still had to make it look big and handmade. We tried to find that balance where a large prop had the charm and fit with everything else, yet seemed believably huge at the same time."

In addition, if a texture becomes too simplified, the computer model offers no help. "The simpler the design is, the harder it is to make it look great in the computer when it's built in three dimensions. There are all these potential pitfalls where it looks like plastic or like cheap computer-game graphics. So there is this fine line that you can't cross," Jessup warns.

In traditional cartoon animation, flat artwork naturally contains two-dimensional cheats that play with the eye. The graphic artist has the freedom to draw something that looks good on paper but wouldn't actually turn around in three dimensions.

Simply put, a graphic image is more easily drawn than built in a computer. Yet *Up* aims to capture that same hand-drawn style in digital depth. According to Scott Clark, "As we moved from the drawing into the actual 3-D world, our job, as animators, was to interpret that drawing into 3-D motion. We had to find the spirit of those drawings."

Conventionally, Pixar has prided itself on layering up the three-dimensional detailing that makes their films feel more plausible, more real to viewers. Returning to the basics of abstraction and caricature is, in some ways, the opposite of what the technical crew has been trying to achieve since the dawn of computer graphics: greater authenticity and believability.

"Simple is not simpler. That's been the hardest thing for me, really, because the details seduce you. You instinctively want to add more," Nierva finds.

GREG DYKSTRA (sculpt), **BRYN IMAGIRE** (set) | digital paint over sculpt | 2006

"This film has been a very difficult struggle against our tendencies, here at Pixar, to do things a certain way," summarizes environment designer Nat McLaughlin. "We tried to push simple shapes. We thought that sort of simple shape language worked best for our film."

Whimsy is a difficult tone to achieve in any form, but the visual language of caricatured shape, texture, color, and style can help to transport the viewer to a fanciful, but plausible, surreality. From the filmmakers' perspective, the hard-won results are well worth the additional effort involved.

"We've made attempts in the past to stylize films and it always tends to get more realistic as we go along. *The Incredibles* was one of our first films to push in that direction [of abstraction]. We wanted *Up* to take it a little bit further," says Lozano.

The storyboard plays a key part in the design, too. Though the art department plans their design work in great detail, all of their work can be for naught unless the story and production crews follow through on the concepts. Jonas Rivera credits his whole team for their consistent approach. "A lot of our design came from the way the story department had staged things."

"This picture's design sense and the design structure were purer than anything that I had worked on," Jessup agrees. "A lot of times, if the story department is not on board with a style from the beginning, it can be a great idea but it gets lost or pushed aside in the process. But Bob, Pete, Ronnie, and Ricky—everybody—made sure that those ideas were carried through."

"That's why we animate something: because it can't be done in live action. It's more fun to watch a caricature," adds Clark. "It's funny to me when animation tries so hard to be realistic. We are showing the audience an artistic interpretation. As Chuck Jones said, 'It's about believability, not realism.'"

Pete Docter and his artists see the world through the same interpretive eyes, allowing audiences to discover a heightened reality on the animated screen. "You know, we're not out taking snapshots of the real world; we're trying to present a caricature, trying to do a cartoon."

"Do everything by hand, even when using the computer."
—Hayao Miyazaki

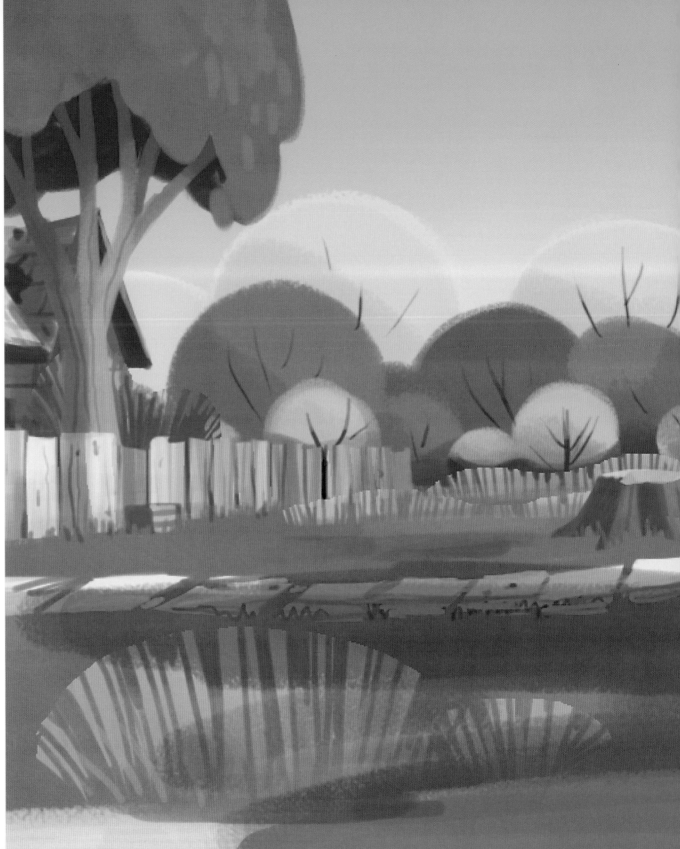

NAT MCLAUGHLIN | digital | 2007

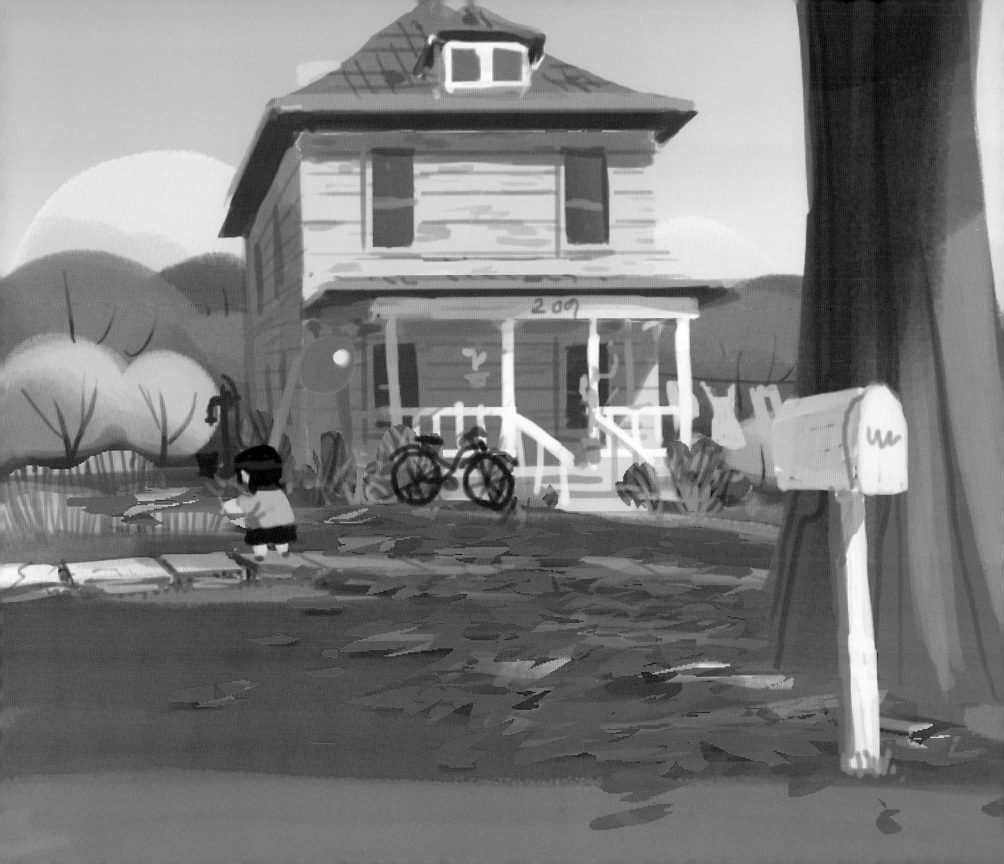

Don Shank, Noah Klocek | digital | 2008

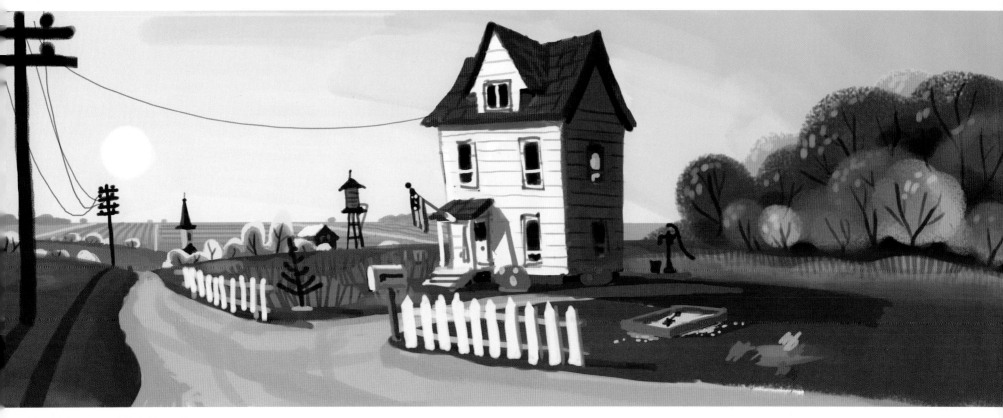

Nat McLaughlin | digital | 2006

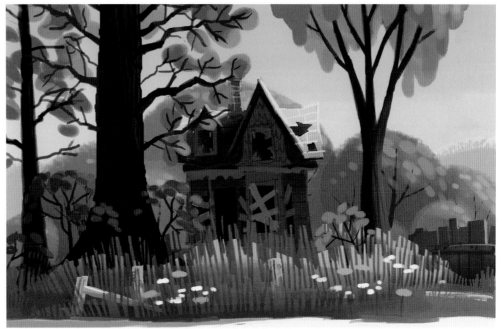

Nat McLaughlin | digital | 2007

HARLEY JESSUP | digital | 2008

DANIEL LÓPEZ MUÑOZ | digital | 2006

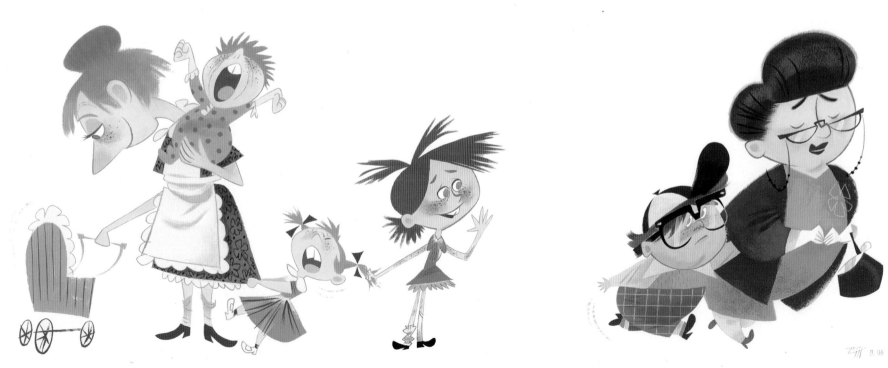

DANIEL LÓPEZ MUÑOZ | gouache | 2006

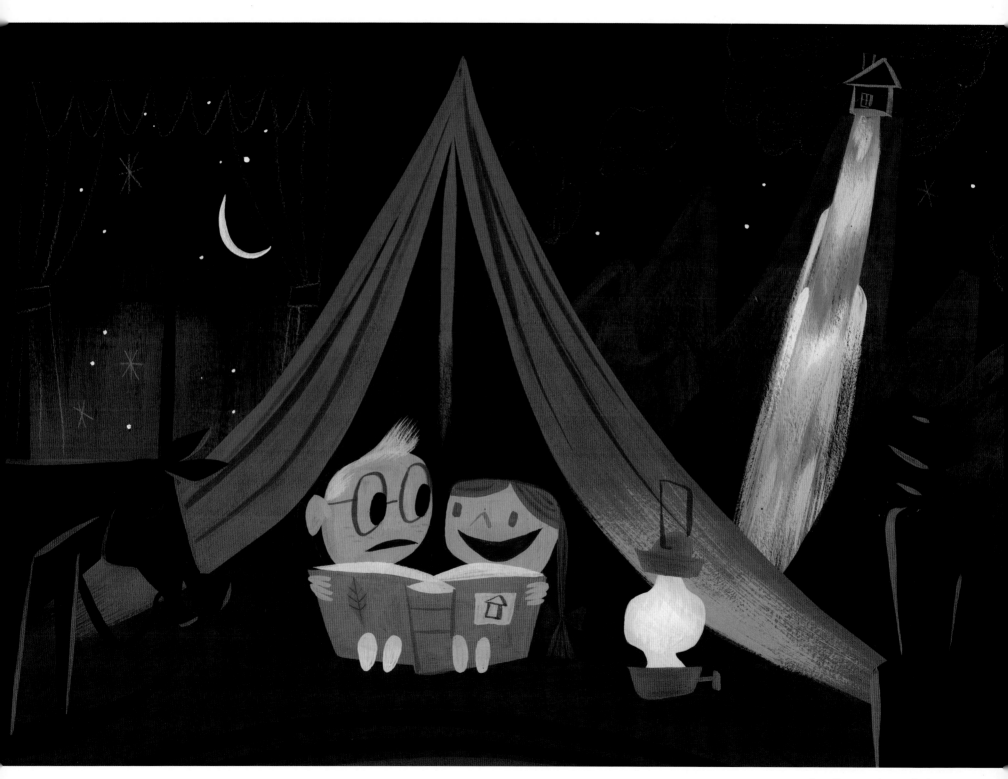

LOU ROMANO | gouache | 2006

"It's very satisfying that Carl brings his Adventure Book back home, because he will always have it to look through to remember Ellie. But now he'll add pictures of him and Russell and his new life to it."
— *Bob Peterson,*
codirector and writer

My Adventure Book

HARLEY JESSUP (art director), ELIE DOCTER (writing/art),
ERIC EVANS (binding) | mixed media | 2008

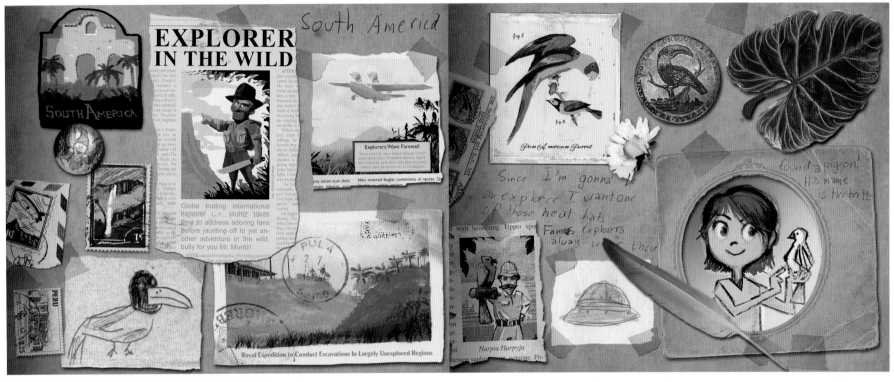

CRAIG FOSTER (graphic design/artist), **ELIE DOCTER** (art) | digital | 2008

"Elie Docter, Pete's daughter, created the childhood drawings and handwriting for the Adventure Book in the film. We tried not to mess with that too much, but the art had to be adapted slightly in order to fit in the various places on the cover and on certain pages. She also drew animals and images of the house. Every drawing that she did was really charming. We were basically trying to get that naive childhood spirit into the book. She did a really beautiful job. No adult could have done this."

— Harley Jessup, designer

ELIE DOCTER | tempera paint | 2008

ELIE DOCTER | pencil and crayon | 2008

"My character, Ellie, has an Adventure Book with all of her drawings in it and some of them will be mine. I drew the pictures when I had turned almost nine and one-half.

The most fun thing about drawing the pictures was that some things could be funny and I could be creative and make animals look the way I think they do.

I think Ellie and her Adventure Book are fun, funny, creative, and adventurous. Ellie really enjoys nature the way we all should, and her journal expresses just that."

— *Elie Docter, voice of young Ellie*

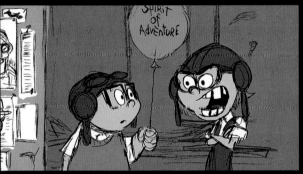

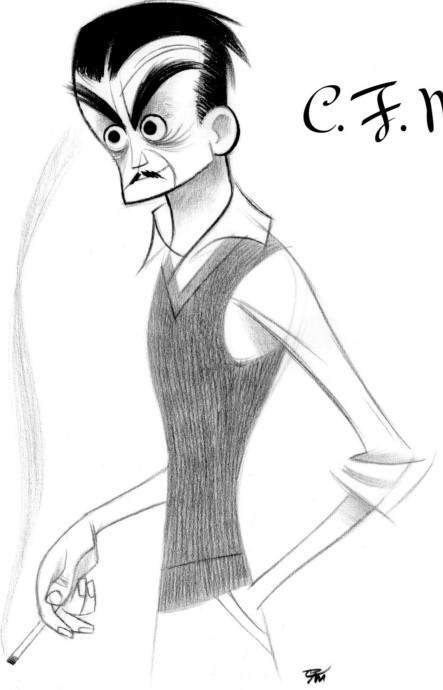

C. F. Muntz

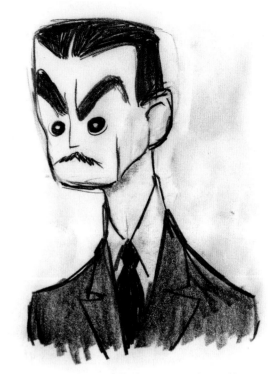

TEDDY NEWTON | pencil | 2006

DANIEL LÓPEZ MUÑOZ | pencil | 2006

CRAIG FOSTER, BILL PRESSING | digital | 2008

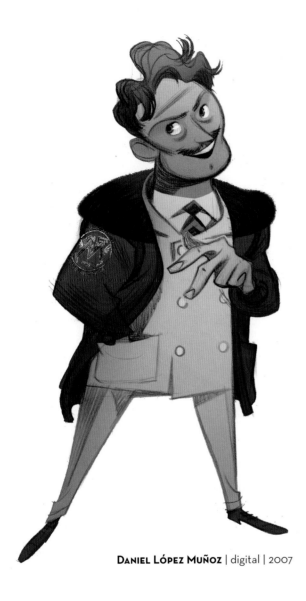

Daniel López Muñoz | digital | 2007

"We wanted to make Muntz look heroic, with broad shoulders and a really strong presence. His shape is like an exclamation point. If you were to blend Erroll Flynn, Clark Gable, Howard Hughes, and Walt Disney into one heroic 1930s man, that would be Muntz."

— *Albert Lozano, designer*

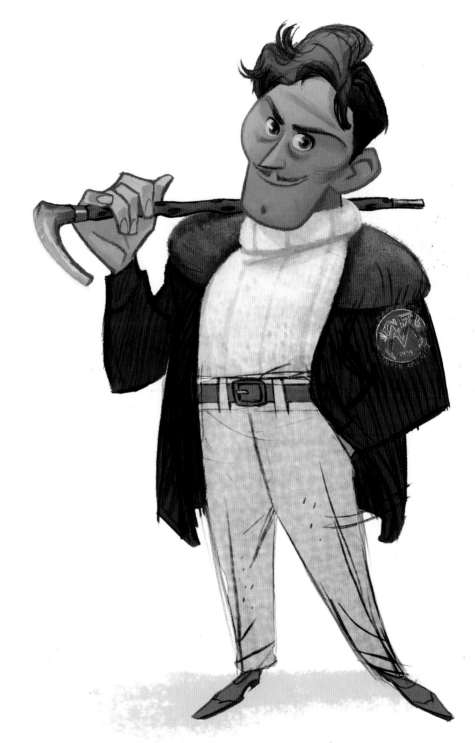

Daniel López Muñoz | digital | 2007

Ellie

"Younger Ellie was wanting to be an adventurer, so she was also an exclamation point, sort of light on her feet and lifting up into the air."

— Albert Lozano, designer

DANIEL LÓPEZ MUÑOZ | colored pencil | 2004

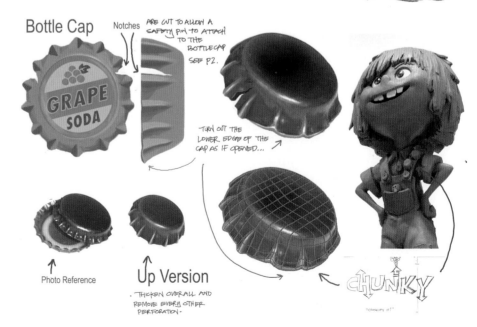

Bottle Cap

Notches

ARE CUT TO ALLOW A SAFETY PIN TO ATTACH TO THE BOTTLECAP SEE P2.

GRAPE SODA

TURN OUT THE LOWER EDGE OF THE CAP AS IF OPENED...

↑ Photo Reference

Úp Version

. THICKEN OVERALL AND REMOVE EVERY OTHER PERFORATION.

CHUNKY

ALBERT LOZANO | colored pencil/digital paint | 2007

ALBERT LOZANO | digital | 2008

"What I like best about *Up* is that Ellie nurses all of the wounded pigeons that boys hit with their slingshots, and I think that is really something only a kid would do."

— Elie Docter, voice of young Ellie

BRYN IMAGIRE | digital | 2007

ALBERT LOZANO | digital | 2006

TONY FUCILE | marker | 2005

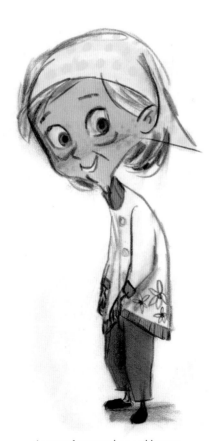

ALBERT LOZANO | pencil | 2007

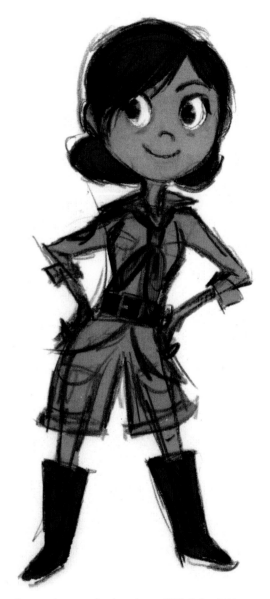

ALBERT LOZANO | colored pencil/digital paint | 2007

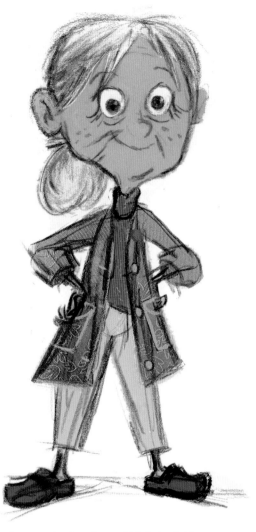

37

ERNESTO NEMESIO | digital | 2008

ALBERT LOZANO | colored pencil/digital paint | 2007

DANIEL LÓPEZ MUÑOZ | digital | 2008

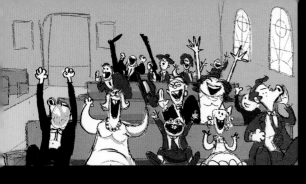
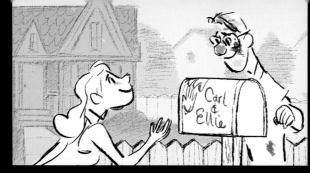
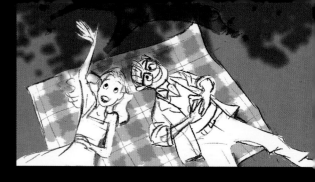
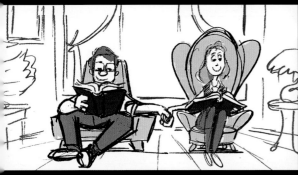

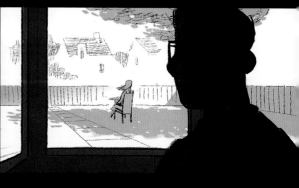

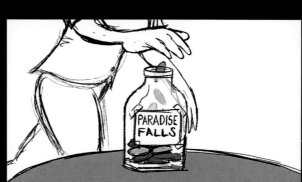
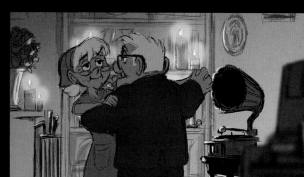
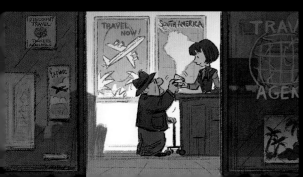
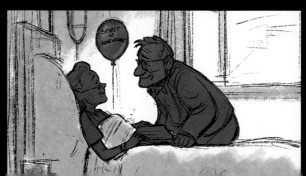

ROB GIBBS, NICK SUNG, RONNIE DEL CARMEN, BILL PRESSING, JOSH COOLEY, JUSTIN HUNT | digital | 2005–2008

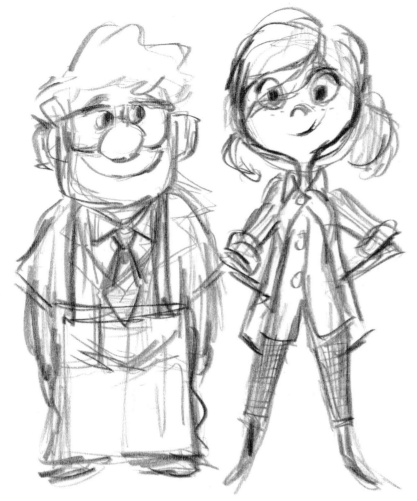

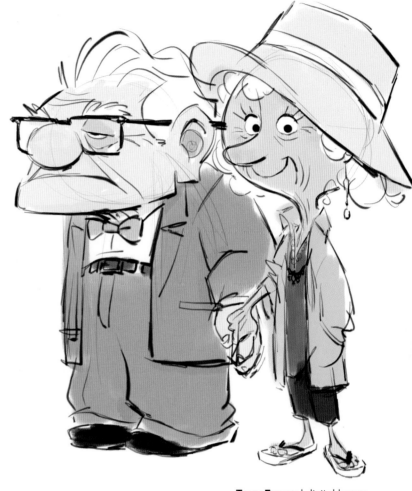

RICKY NIERVA | colored pencil | 2007

TONY FUCILE | digital | 2005

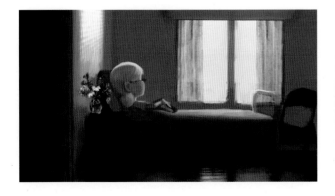

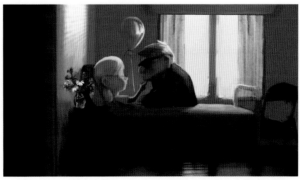

DANIEL LÓPEZ MUÑOZ | digital | 2008

Carl

"Carl is a box, a heavy brick, because of how close to the ground he has sunk. After the death of his wife, he has shut off the world around him. So he's stuck in his ways, very square. Impenetrable. Unmovable. There's heaviness to his soul. It's easy to read that he has been through a lot."

— Daniel López Muñoz, designer

RICKY NIERVA | marker | 2004

RICKY NIERVA | digital | 2004

RICKY NIERVA | marker | 2005

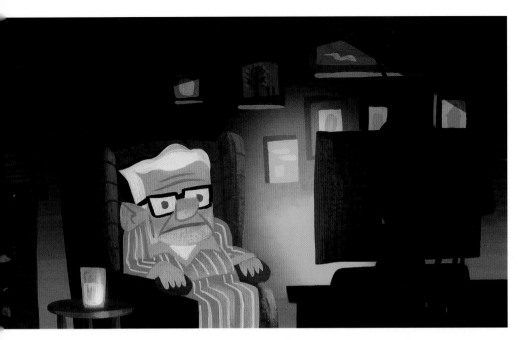

LOU ROMANO | gouache | 2006

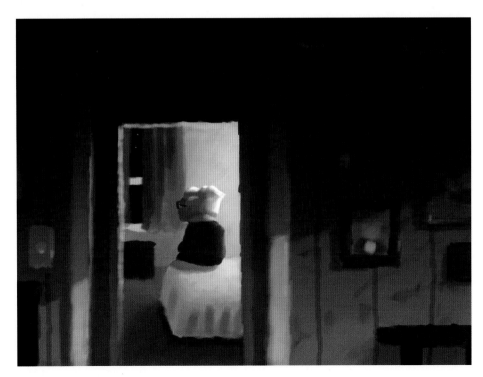

LOU ROMANO | digital | 2005

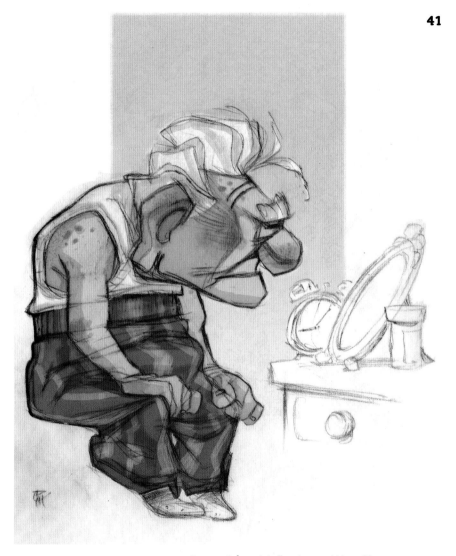

DANIEL LÓPEZ MUÑOZ | pencil/digital | 2006

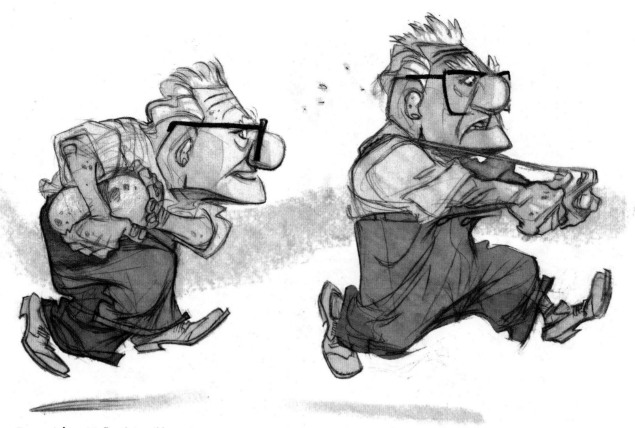

Daniel López Muñoz | pencil | 2006

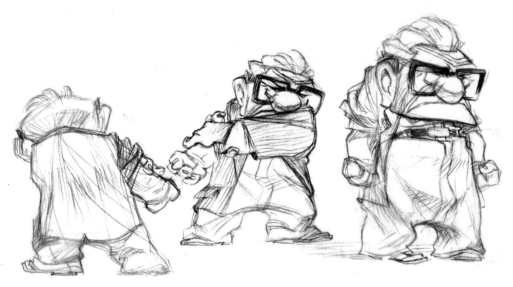

Daniel López Muñoz | pencil | 2006

"Carl's clothing was extremely caricatured.
His silhouette needed to look like a square
when he was wearing clothes. But what
did his underlying body need to look like
in order to support that design? We had to
guess what his body shape should look like,
think of it as a skeleton for his clothes."

—Thomas Jordan,
character supervisor

"Carl was only three heads high and he had these little nubby arms, but he still needed to be able to touch his face or grab something over his head. As we started to pose him in animation we realized that he couldn't touch his face, so we'd have to stretch his arm or create some visual cheat."

— Scott Clark, supervising animator

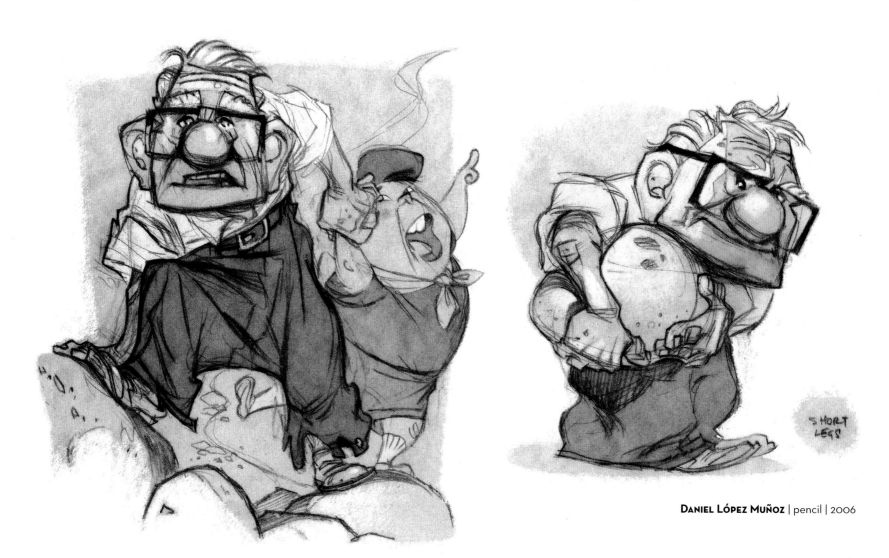

DANIEL LÓPEZ MUÑOZ | pencil | 2006

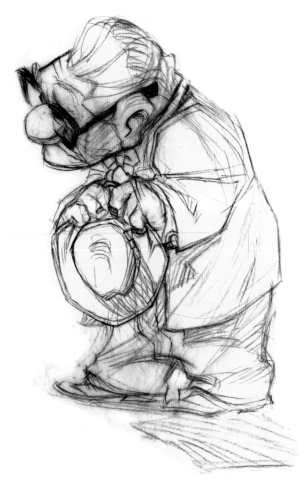

DANIEL LÓPEZ MUÑOZ | pencil | 2006

"Except for Mr. Potato Head, Carl is probably
the first time we've had a character that's
only three heads high."

— Dave Mullins,
directing animator

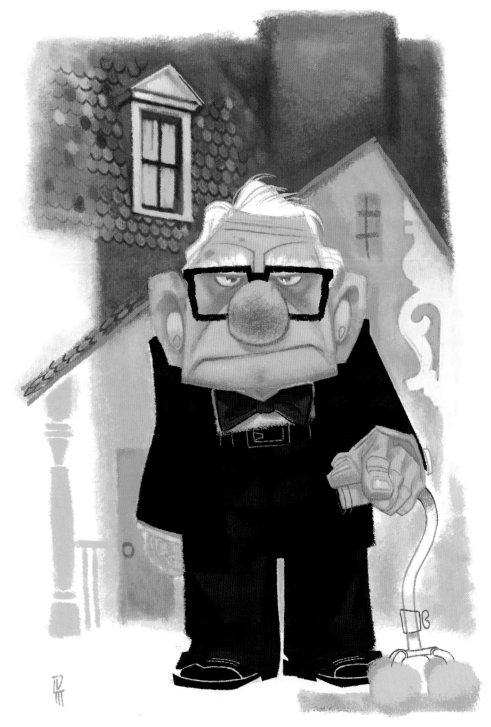

DANIEL LÓPEZ MUÑOZ | digital | 2006

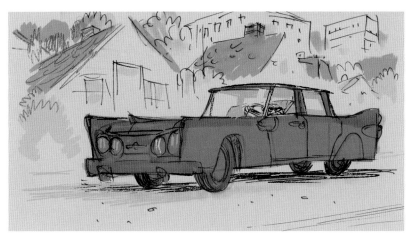

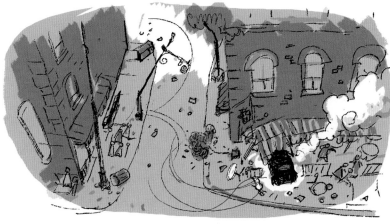

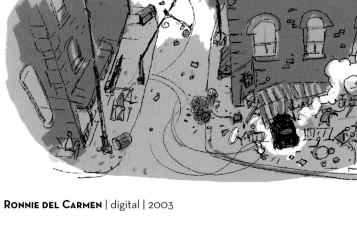

RONNIE DEL CARMEN | digital | 2003

DANIEL LÓPEZ MUÑOZ | digital | 2006

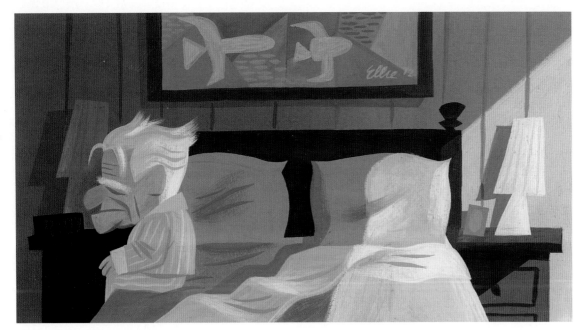

LOU ROMANO | gouache | 2005

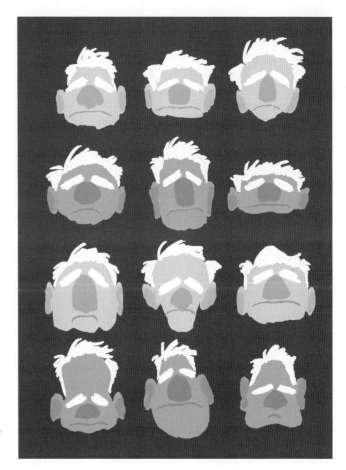

PETE SOHN | digital | 2005

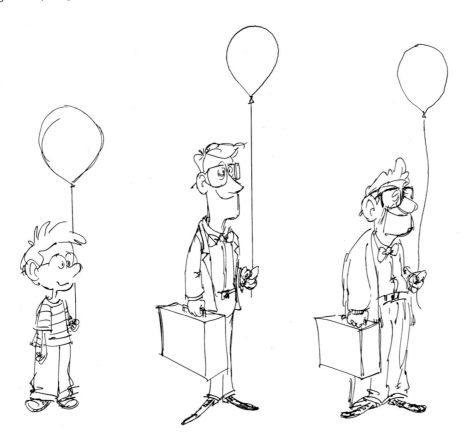

RICKY NIERVA | ink | 2005

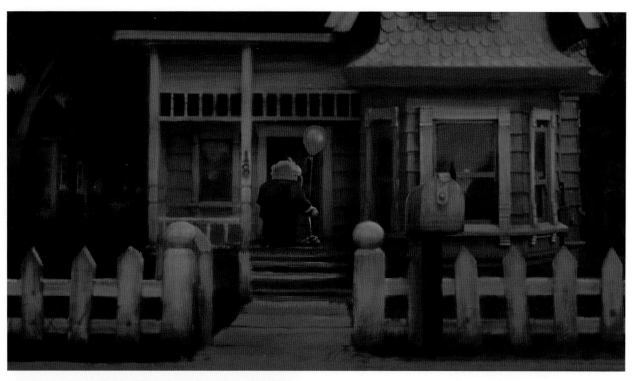

Daniel López Muñoz | digital | 2008

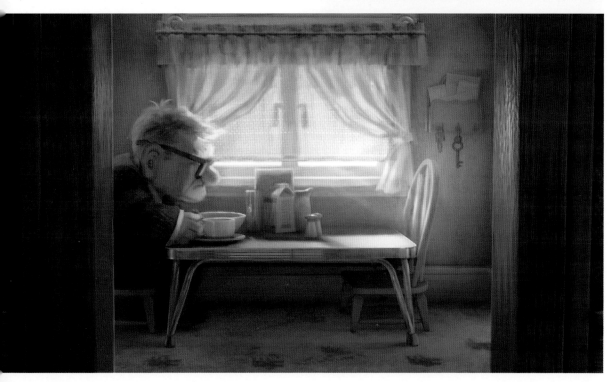

Daniel López Muñoz | digital | 2008

48

ALBERT LOZANO | digital | 2006

"Carl, from belt to neck, is pretty stiff. He's like a turtle. He can't turn his head, but turns his whole body. That's built into the character design, but it's also how humans work. As we get older, our skeleton fuses and it hurts to twist and bend."

— *Scott Clark, supervising animator*

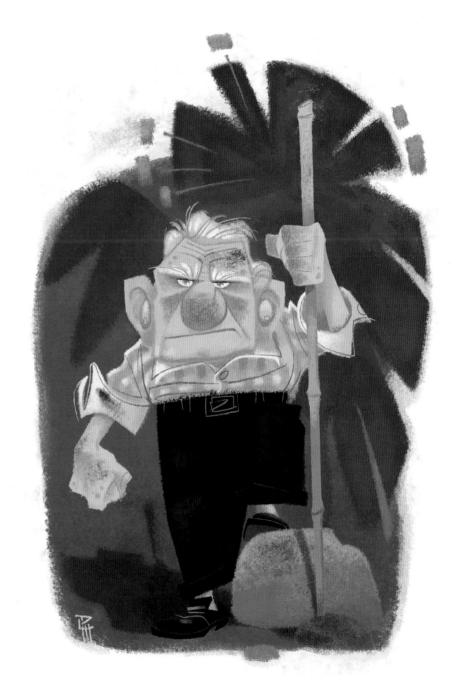

DANIEL LÓPEZ MUÑOZ | digital | 2006

"Carl starts this movie with the weight of Ellie's loss on his shoulders. But through his adventure, Carl transcends that weight. He literally straightens up and becomes a younger, more hopeful soul."
— Bob Peterson,
codirector and writer

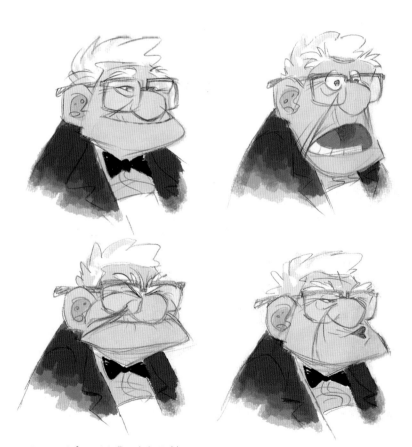

DANIEL LÓPEZ MUÑOZ | digital | 2006

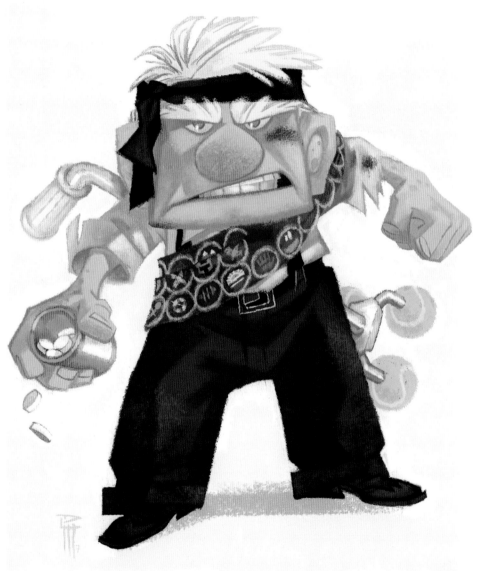

DANIEL LÓPEZ MUÑOZ | digital | 2007

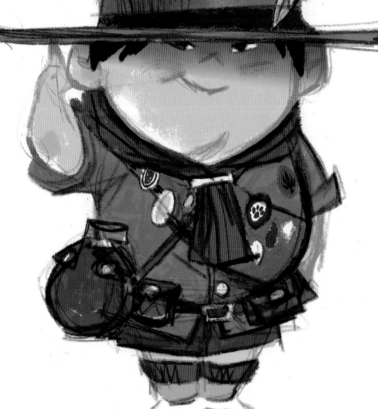

Russell

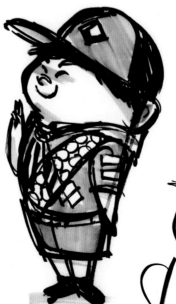

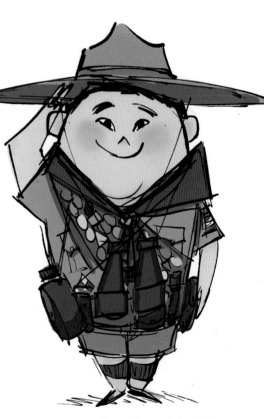

DANIEL LÓPEZ MUÑOZ | pencil/digital | 2006

RICKY NIERVA | marker | 2005

RICKY NIERVA | digital | 2006

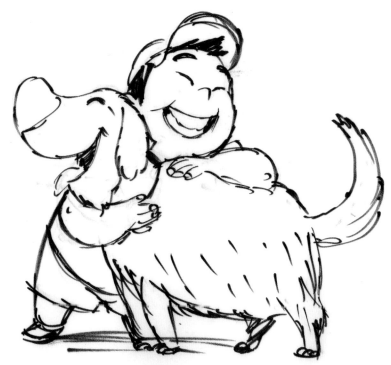

Daniel López Muñoz | marker | 2006

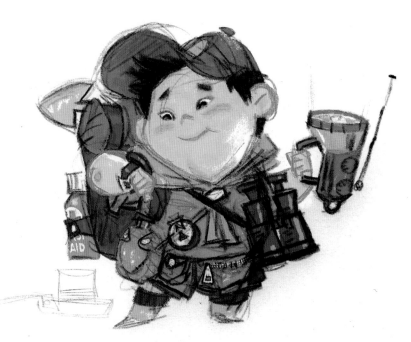

Daniel López Muñoz | pencil/digital | 2006

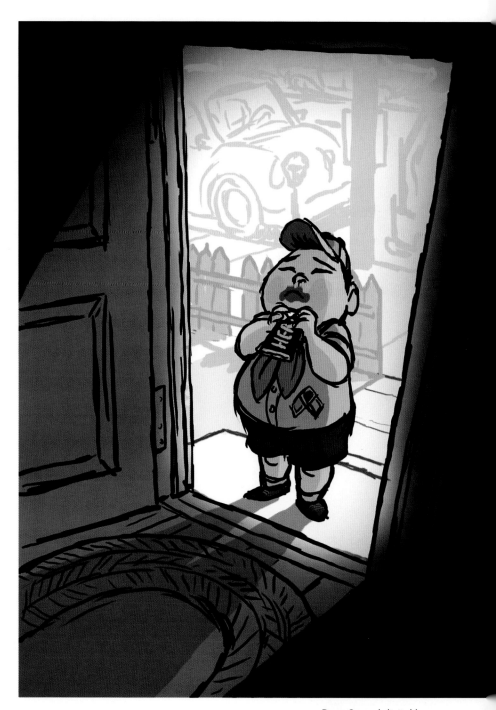

Pete Sohn | digital | 2005

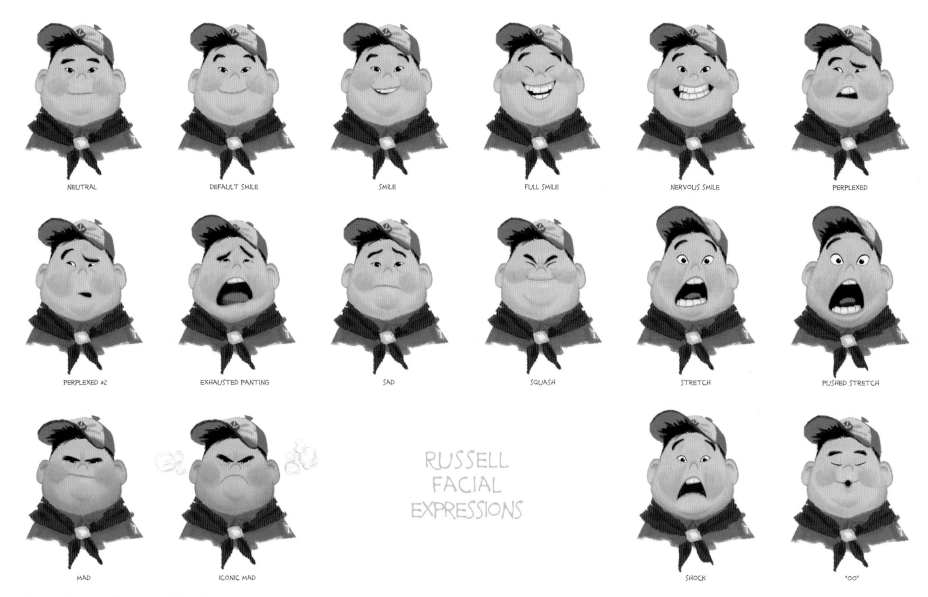

NEUTRAL DEFAULT SMILE SMILE FULL SMILE NERVOUS SMILE PERPLEXED

PERPLEXED #2 EXHAUSTED PANTING SAD SQUASH STRETCH PUSHED STRETCH

MAD ICONIC MAD

RUSSELL
FACIAL
EXPRESSIONS

SHOCK "OO"

DANIEL LÓPEZ MUÑOZ | pencil/digital | 2007

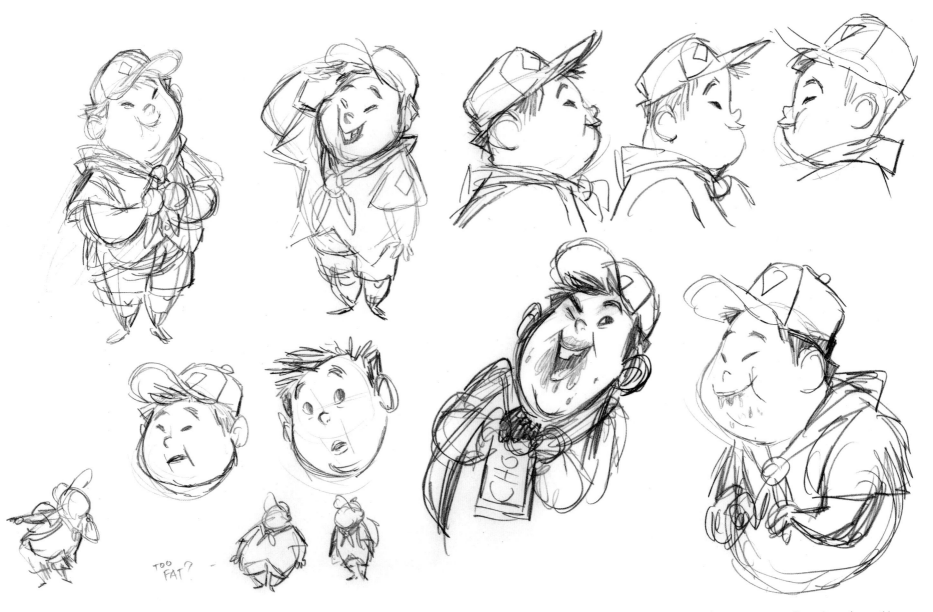

TOO FAT?

PETE SOHN | pencil | 2005

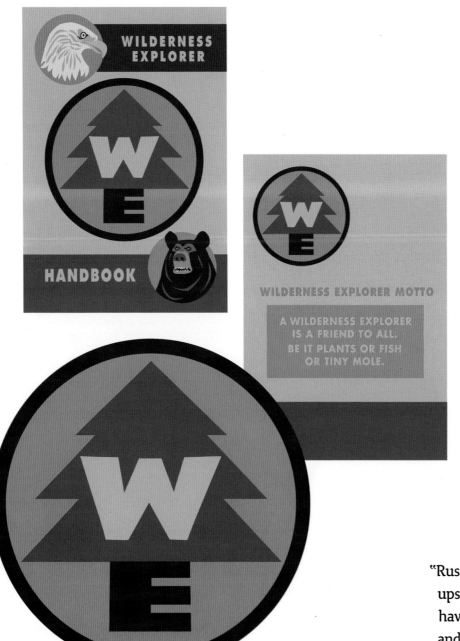

54

WILDERNESS EXPLORER

W E

HANDBOOK

WILDERNESS EXPLORER MOTTO

A WILDERNESS EXPLORER
IS A FRIEND TO ALL.
BE IT PLANTS OR FISH
OR TINY MOLE.

W E

PAUL CONRAD | digital | 2008

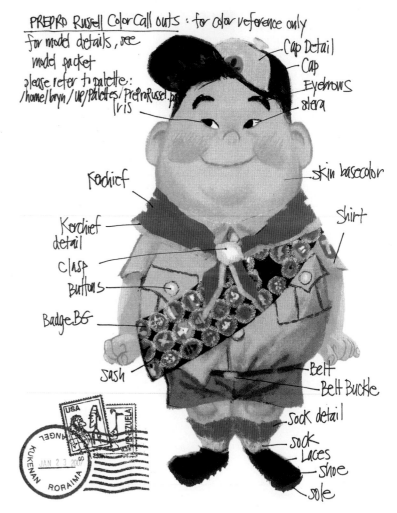

PREPRO Russell Color Call outs : for color reference only
for model details, see
model packet
please refer to palette:
/home/bryn/UP/Palettes/PreproRussel.p

Cap Detail
Cap
Eyebrows
Iris
sclera

Kerchief

skin basecolor

Kerchief
detail

Shirt

Clasp

Buttons

Badge BG

Sash

Belt
Belt Buckle

Sock detail

Sock
Laces
Shoe
Sole

BRYN IMAGIRE | digital | 2007

"Russell is supposed to be an oval shape, almost like an
upside-down egg. So his neck—well, he doesn't really
have one. It's so stylized that the silhouette of his head
and body all together looks like an oval."

—*Thomas Jordan, character supervisor*

55

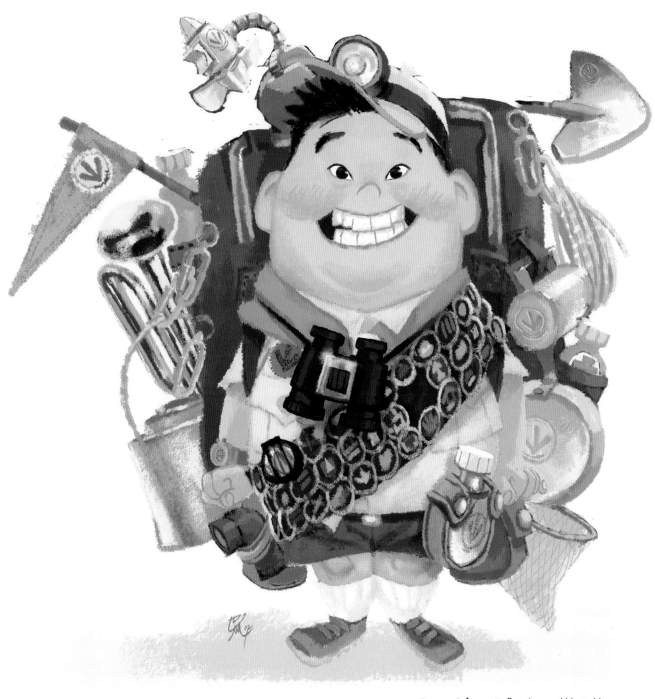

Sculpture

"The saying 'A picture is worth a thousand
words' is very true, but I think in our
business you could go with 'A sculpture
is worth a thousand pictures.'"
— Greg Dykstra, sculptor

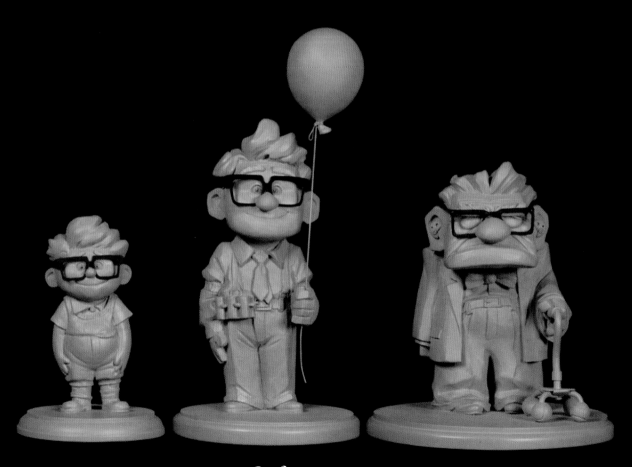

Carl

"I've learned a lot about aging. How does the human face change over the years? We've built three models of Carl and three of Ellie and these all have to look like the same person, but at different ages. What is it about a human face that allows you to quickly read how old they are?"

— Thomas Jordan, character supervisor

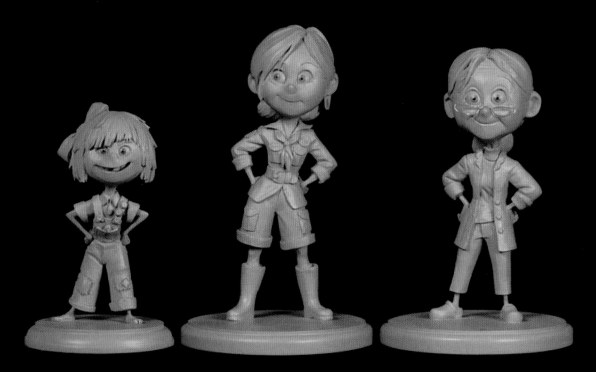

Ellie

GREG DYKSTRA | cast urethane | 2005-2008

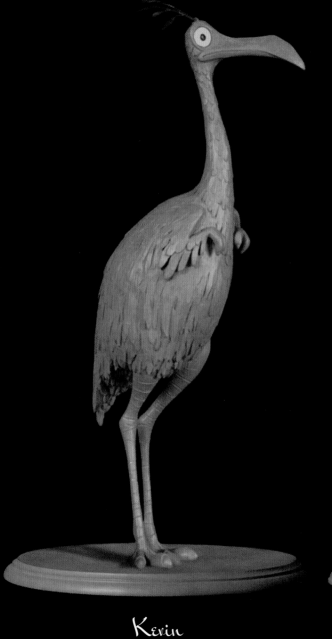

"Sometimes you don't know how well a character design is going to work in the computer until you start to see it move. Making it move can become so difficult that functional changes will need to be made for animation. I try to solve those problems in sculpture so the design can look good from all angles."

— Greg Dykstra, sculptor

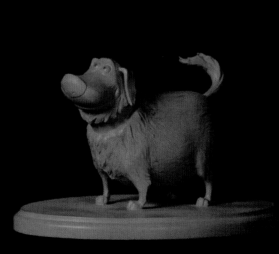

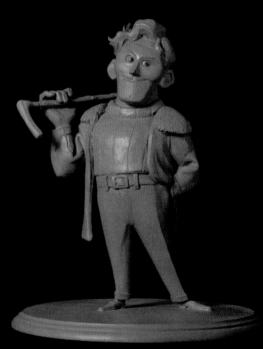

Kevin

Russell

Dug

C. F. Muntz

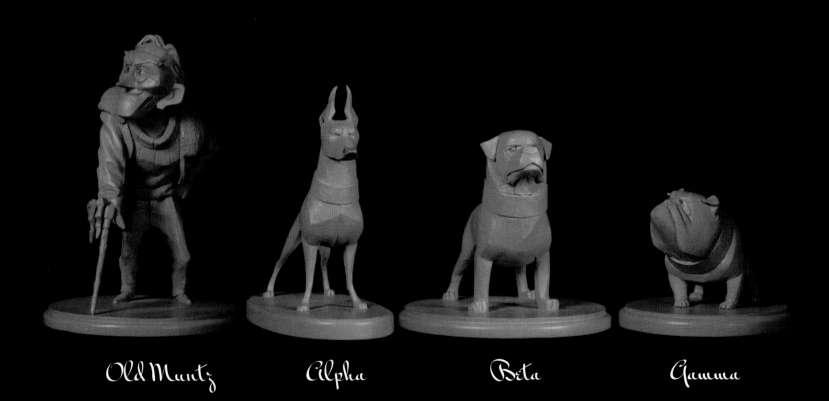

"To convey personality, we try to think of every little detail, like how they wear their shirt or how they comb their hair. How much time would this character take to groom themselves in the morning? What kind of presentation do they want to give to the world? What is their posture?"

— Greg Dykstra, sculptor

Old Muntz Alpha Beta Gamma

GREG DYKSTRA | cast urethane | 2005–2007

Extras

"Albert is like our casting director—except that he designs our 'extras' rather than finding them. Casting that perfect character can make or break a scene and Albert is really good at knowing what a scene needs and then creatively revising characters."

— Pete Docter, director

ALBERT LOZANO | pencil/digital | 2007

ALBERT LOZANO | pencil/digital | 2008

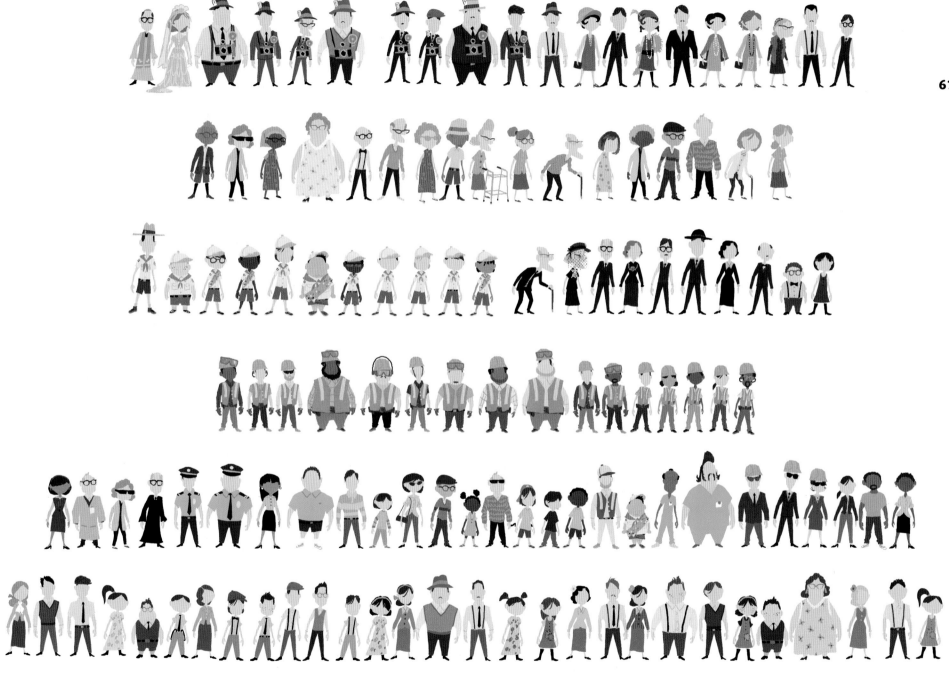

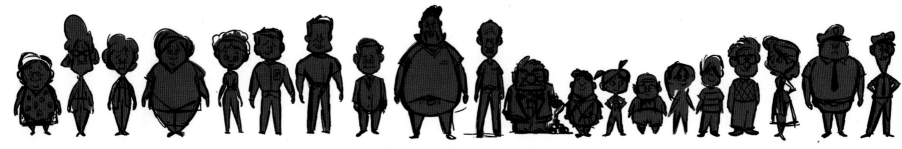

ALBERT LOZANO | digital | 2007

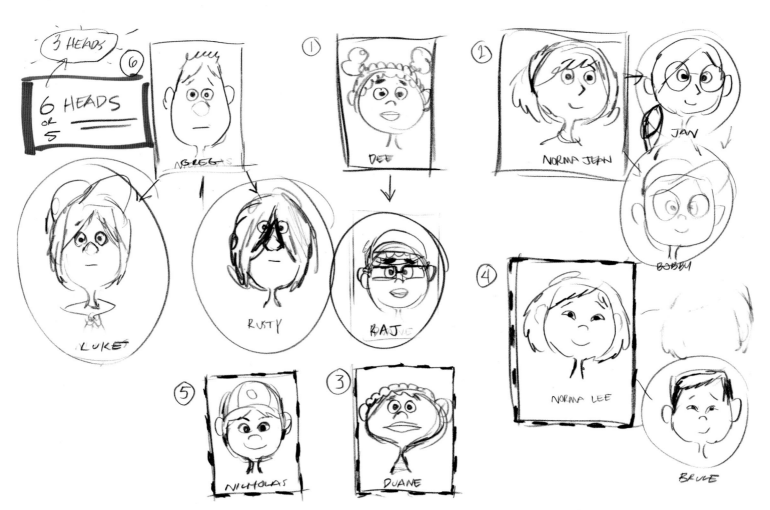

ALBERT LOZANO | pencil | 2007

RICKY NIERVA | pencil | 2005

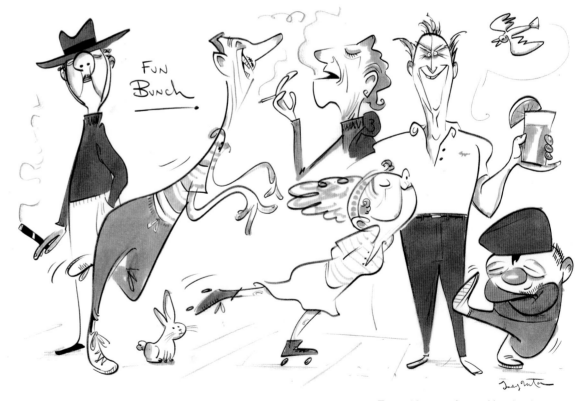

FUN BUNCH

"The Fun Bunch is a group of elderly, but lively and energetic, residents from Shady Oaks Retirement. In one version of the story, they attempt to coax Carl into giving up his house."

— Pete Docter, director

TEDDY NEWTON | pencil/marker | 2005

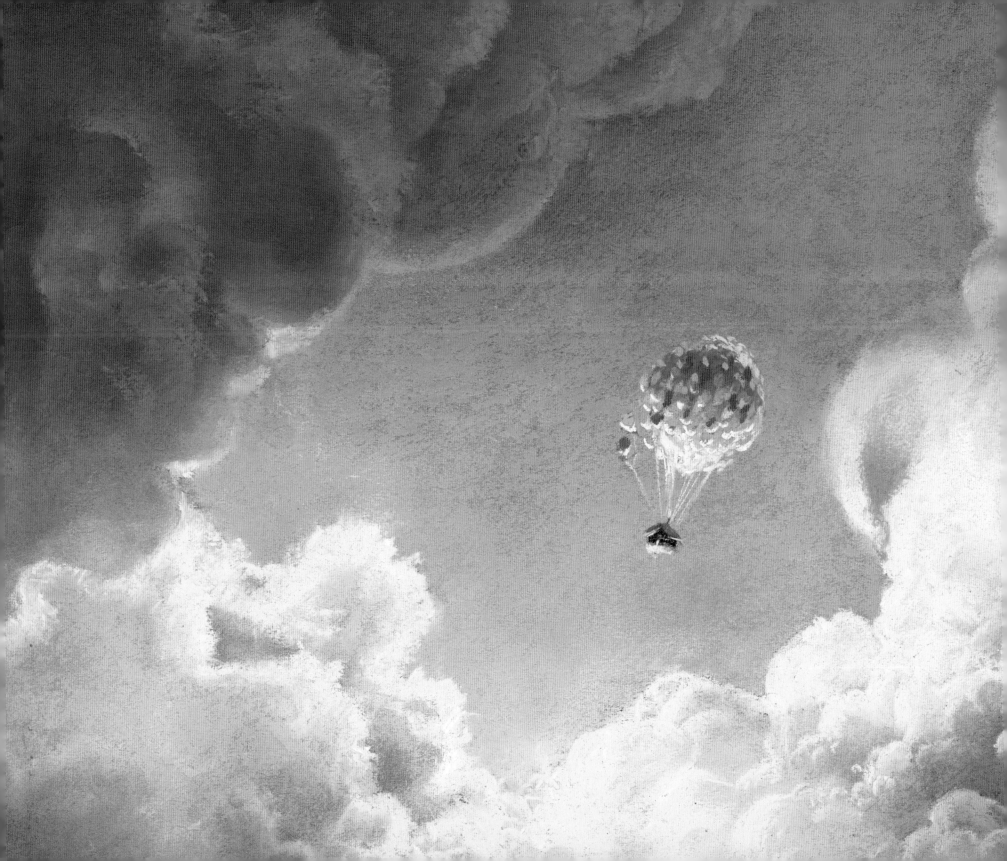

NO PLACE LIKE HOME

"We 'cast' the house in the same way you would select just the right actor for a role. We took field trips into Oakland and Berkeley looking for old, charming small houses. Carl's house is a combination of several houses we found and liked. Since it needed to float, we stayed away from heavy-looking elements like brick and stucco and even heavy rugged styles like Craftsman. Victorian is a great blend of light, ornate, and old world. It seemed to fit the bill quite well."

— Pete Docter, director

ADVENTURE STORIES OFTEN BEGIN AT home and then leave it far behind as the journey begins. *Up* takes that idea a little farther by bringing Carl's house along for the entire ride. Call it a new twist on the mobile home.

"We thought of Carl's house as a character in the film. To my knowledge, it's one of the most extensive models we've built, because it moves all through the film," says environment designer Don Shank.

"This house is flying all over the place," adds sets supervisor John Halstead, "There was a lot of work for animation and effects in there."

CGI set builders can often cheat on props. Take a bookshelf, for example. Typically, artists might consider using a false front for a row of stationary books, like those found on a theater or film set. But because Carl's house moves around, causing books to fall off the shelf, each volume had to be constructed individually.

In *Up*, Halstead reminds us, an array of household items become animated casualties on the flight to South America. As a result, "there had to be a detailed surface behind the pictures on the wall, because the pictures would swing out of the way to show the faded outline of the frame that had hung there for fifty years. Carpets normally don't have to be animated. But in this house, a chair would slide against the rug and the rug would crumple against the wall. So this set was challenging because almost everything had to move."

Carl's house was not only required to move, but to be emotionally *moving* as well. It was a silent actor. Nat McLaughlin helped the environment convey proper emotion for a scene. "Early on in the story we show Carl alone in his house. It's got this shut-in feeling. Carl is a guy who has gone into hibernation since his wife died. So his house reflects this. It's become a cave, a squared-off cage."

"Carl's house certainly has a sadness to it. But we also wanted it to feel comfortable and lived-in and show all those little nuances that have made this his home," says Jonas Rivera.

Ricky Nierva conjures a vision of mismatched gingerbread, Hummel figurines, mothballs, and cuckoo clocks familiar to anyone who has gone over the river and through the woods to see a grandparent. "The atmosphere in Carl's home was based on the theme 'It's the simple things that you remember,'" he recounts. "Even if he's lived a simple life, an old man accumulates a lot of stuff throughout the years. We wanted to infuse that sense of history into every little item in Carl's house."

"We were trying to make Carl's house *look* like your grandparents' house *smelled*," quips Rivera.

To get the details just right, Rivera scheduled a research trip to his own grandparents' house, to better examine the species known as "senior citizen"

(Right) **DON SHANK** | digital | 2005
(Previous spread) **DOMINIQUE LOUIS** | pastel | 2005

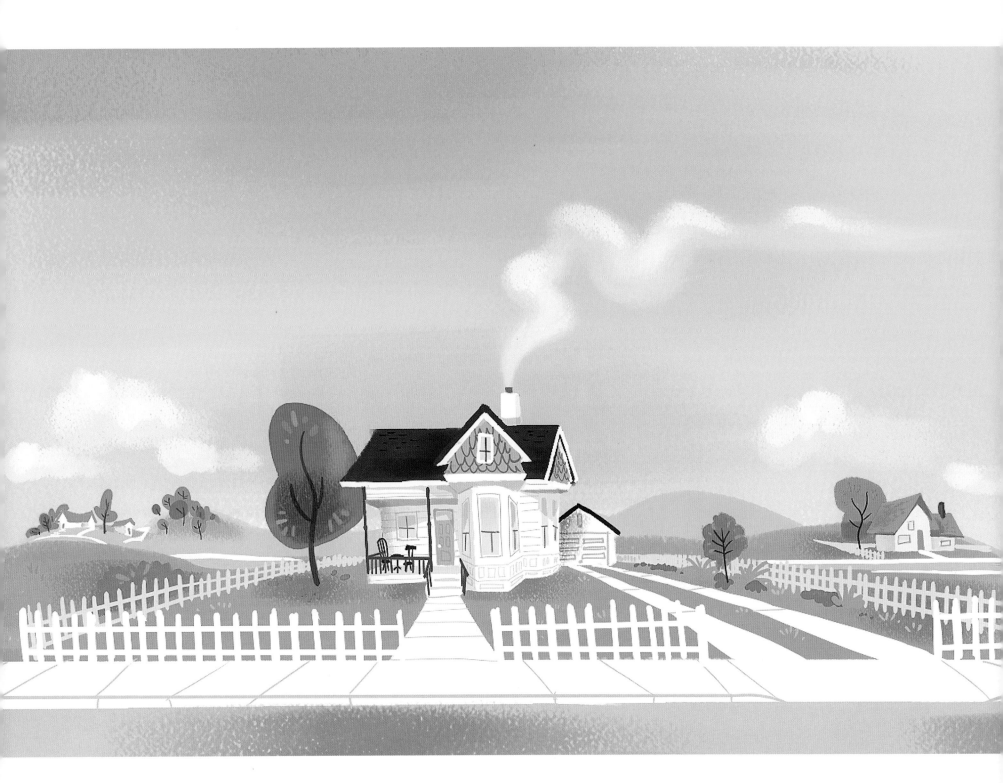

in its natural habitat. "We set up a video camera, brought in sandwiches, and just observed the conversation. My grandfather is in his eighties and he'd sit there and tell his stories. We were after the authenticity of how someone that age speaks and reacts."

Bob Peterson took his research one step beyond with a reference trip through time: "My grandparents passed away in 1988. After they died I went through their house with a video camera recording it as it was before anything had changed. It was truly powerful seeing chairs that are just sitting there empty or all those photographs from the fifties and sixties. You notice how the layers of things in the house have built on the past. It's almost like archeology, there's just so much there. It tells so much of the story of a life lived just by the little tiny tchotchkes that they had."

All of these well-observed nuances help to create a mood, a moment, a resonant sense of place critical to conveying the deep emotional threads of Carl's story. Production designers placed nostalgic ephemera throughout Carl's house—receipts and little treasures on the mantle, postcards that are tucked behind a mirror.

"We used that layering to help sell that feeling of the passing of time. But we didn't want to do it *too* much because it would start cluttering up the house. And we wanted to keep that simplicity of design," says Nierva. "That was a hard thing to do in CG—and for the look of this movie, because we were purposely pulling detail away from our designs like Mary Blair did. Mary Blair was trying to minimize detail, to express the essence of things."

Production stylist Mary Blair lent her fanciful folk-art sensibility to a string of Walt Disney classics, from *The Three Caballeros* and *Cinderella* to *Alice in Wonderland* and *Peter Pan*. Blair's inspirational preproduction art interpreted the world with a color-saturated childlike simplicity. Her charming art direction for the Disney short subject *The Little House* (1952) was of particular relevance to the design of Carl's small, small world.

"We all loved the crisp, fresh drawings of Mary Blair; and since she always worked in flat colors with interesting shapes, it seemed that her work could be animated with wonderful results," wrote directing animators Frank Thomas and Ollie Johnston in *Disney Animation: The Illusion of Life*. "Although we kept the colors, the relative shapes, and the proportions, once Mary's drawings began to move by the principles of animation that Walt had decreed, they often lost the spirit of her design."

DON SHANK | digital | 2005

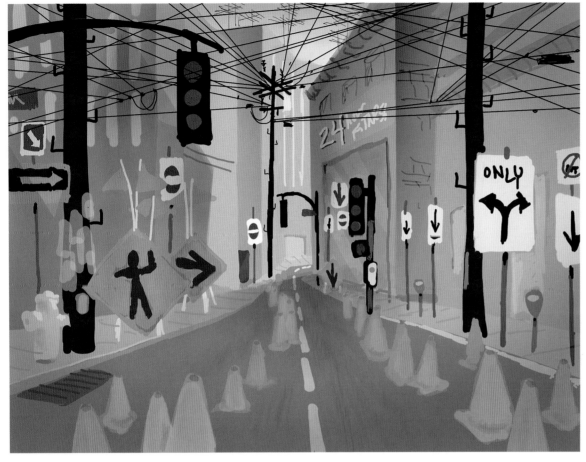

DON SHANK | digital | 2005

Even when significantly modified for the screen, Blair's colorful visions for Wonderland and Never Land proved to be iconic, indelible interpretations. Animator Marc Davis said of Blair, "She brought modern art to Walt in a way that no one else did. He was so excited about her work."

Though Blair's influence can be seen in the warm, nostalgic glow of Carl Fredricksen's home, simplicity in CGI is always a relative thing.

"For the most part, Carl's house was built like a real house," says environment designer Don Shank. "We had an architect come in and he worked with us on what a real foundation would be like for a house built in that era. Taking that information, we simplified it a little bit, but we still wanted it to be totally believable. What it ultimately meant was that all these individual boards and rafters and joints had to be built by a computer."

To provide a reference for the house in the film, texture specialist Bryn Imagire teamed with technical director Neftali Alvarez to build and paint a physical miniature model home. "For the digital images, we were able to duplicate all of these miniature paint techniques that made the house feel really old, but not decrepit. We were able to get the essence of old age or wearing, but without becoming photo-realistic. The final result was very loose and impressionistic."

"No matter how dreary and gray our homes are, we people of flesh and blood would rather live there than in any other country, be it ever so beautiful. There is no place like home."

— *Dorothy, The Wonderful Wizard of Oz*

Toward the beginning of the film, we see that Carl has new neighbors, much to his chagrin. Imagine has planned the surrounding cityscape to be much more literal than the old-timer's romanticized home. To achieve the scale difference between the house and these other environments, she creates contrasts in the virtual materials used for construction, "so the new buildings are hard; the colors are cooler. Inside the house we were trying to use more homey, more nubbly, comfortable textures, not so glossy, just to get that homemade feel."

To denote the passage of time, the designers planned a similar contrast between Carl's neighborhood when he was a young boy, as seen in the film's opening scenes, and what it had become by the time of Carl's senior dilemma. The former was envisioned as a nice Midwestern suburb with rounded hills and lanes lined by elm trees—an inviting, nostalgic environment. The latter is a steel and concrete wall of malls and half-built structures that is closing in on Carl's lonely little house. The urban encroachment of these looming, boxy shapes creates a claustrophobic tension.

"Our idea was that Carl lived in Squaresville and his house was the only thing left," says Noah Klocek. "That's Squaresville—not in the old sense of the term—but in the modern sense of big-box stores and cookie-cutter houses and everything that's square and stucco."

As the balloons hoist the house into the sky, we are treated to a tour of the film's basic design theory, laid out on the ground below. The shapes on Carl's horizon illustrate his process of change during the voyage. The trip starts out on the small, square Fredrickson plot surrounded by a grid of girders, bricks, and machinery. Everything in the area is new. The only trees are tiny saplings. As Carl moves through the city, the landscape evolves to include older buildings, rounder shapes, and more trees. When the balloonist floats out of the city into the countryside, the trees and hills become rounder in shape and more plentiful, and viewers can visualize the old man escaping his bland, square world.

For the audience to buy into that flight, the film's fantasy physics must follow an internal logic. Like so many aspects of the film's design, they needed to be believable within the context of that fantastical world. And so it was with Carl's balloon-powered flight.

"How many balloons does it take to float a house?" poses Docter. "We were thinking that if we could

mimic the shape and proportions of a hot-air balloon to basket in relation to the canopy of balloons to Carl's house, then it seems like you'd buy that logic. And sure enough, that seemed to work."

"One of the things we did was create very realistic balloon animation," adds technical director Steve May. "Each balloon was buoyant and could bounce off the others. Each one had a string. When you see that kind of realistic behavior reproduced in thousands of balloons, you buy that a house could be lifted up."

The enormous effort put into creating a physical logic and appealing atmosphere in Carl's world from the ground up is intended to help sell the story, but Don Shank hopes it might also inspire prospective homeowners. "I'd like the audience to feel that this was a cool world that they would want to live in. That's what attracted me to cartoons in the first place. I wanted to live in Bedrock with Fred Flintstone or in Alice's Wonderland forest. If people would love to live in Carl's house, then I have done my job well."

"Don Shank has this amazing sense of style to his drawings. As he took on the job of designing Carl's house, he was able to insert that style and balance it with the necessary structural and architectural details to make it feel believable."

— Pete Docter, director

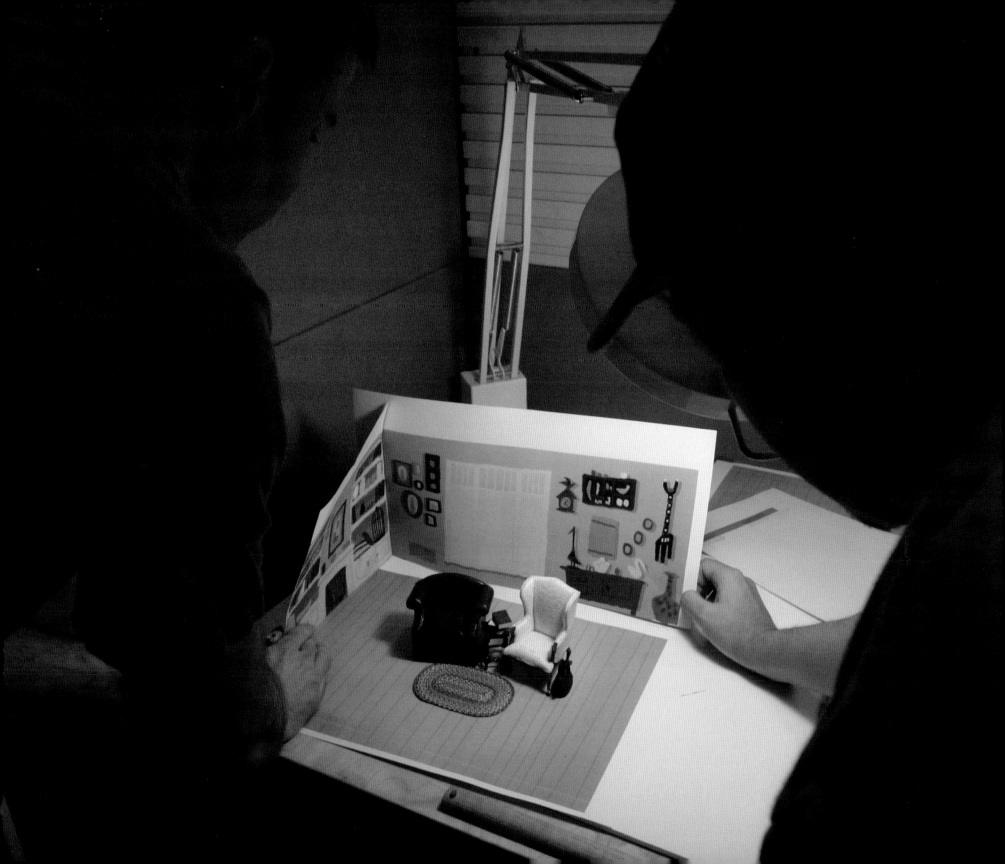

The House

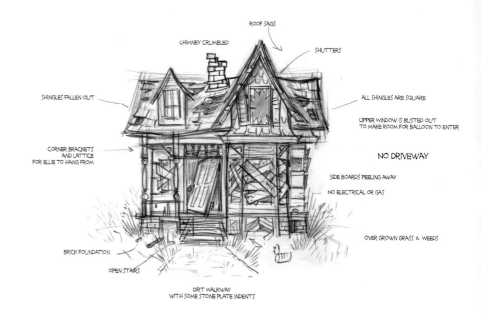

CLUBHOUSE

ROOF SAGS

CHIMNEY CRUMBLED

SHUTTERS

SHINGLES FALLEN OUT

ALL SHINGLES ARE SQUARE

UPPER WINDOW IS BUSTED OUT
TO MAKE ROOM FOR BALLOON TO ENTER

CORNER BRACKETS
AND LATTICE
FOR ELLIE TO HANG FROM

NO DRIVEWAY

SIDE BOARDS PEELING AWAY

NO ELECTRICAL OR GAS

OVER GROWN GRASS & WEEDS

BRICK FOUNDATION

OPEN STAIRS

DIRT WALKWAY
WITH SOME STONE PLATE INDENTS

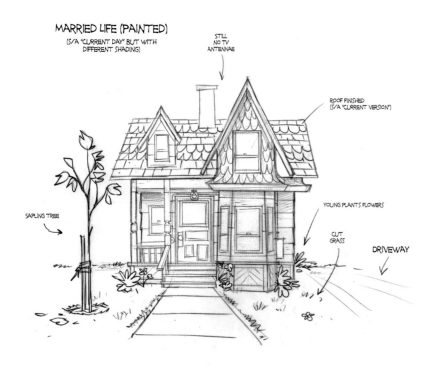

MARRIED LIFE (PAINTED)

(S/A "CURRENT DAY" BUT WITH
DIFFERENT SHADING)

STILL
NO TV
ANTENNAE

ROOF FINISHED
(S/A "CURRENT VERSION")

YOUNG PLANTS FLOWERS

CUT
GRASS

DRIVEWAY

SAPLING TREE

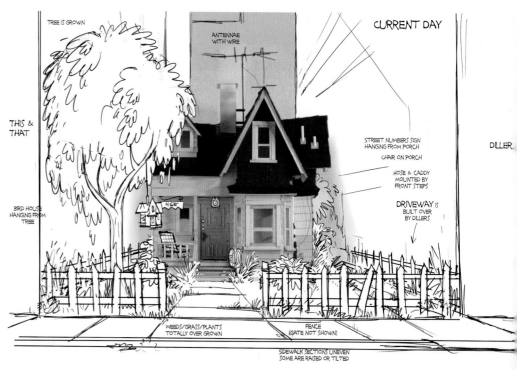

TREE IS GROWN

ANTENNAE
WITH WIRE

CURRENT DAY

THIS &
THAT

STREET NUMBERS SIGN
HANGING FROM PORCH

CHAIR ON PORCH

DILLER

HOSE & CADDY
MOUNTED BY
FRONT STEPS

BIRD HOUSE
HANGING FROM
TREE

DRIVEWAY IS
BUILT OVER
BY DILLERS

WEEDS/GRASS/PLANTS
TOTALLY OVER GROWN

FENCE
(GATE NOT SHOWN)

SIDEWALK SECTIONS UNEVEN
SOME ARE RAISED OR TILTED

DILAPITATED EXTREME

(S/A CLUBHOUSE MODEL – BUT WITH
DRESSED IN BROKEN BITS)

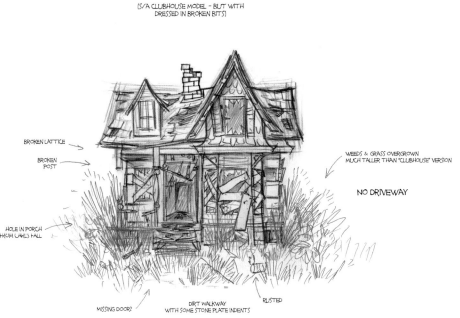

BROKEN LATTICE

BROKEN
POST

HOLE IN PORCH
FROM CARL'S FALL

MISSING DOOR?

DIRT WALKWAY
WITH SOME STONE PLATE INDENTS

RUSTED

WEEDS & GRASS OVERGROWN
MUCH TALLER THAN "CLUBHOUSE" VERSION

NO DRIVEWAY

RENOVATING

(S/A "CURRENT DAY" MODEL BUT WITH
ALTERNATE SHADERS AND DRESSED ELEMENTS
ALSO – ROOF SAG WILL BE STRAIGHTENED IN PAINT)

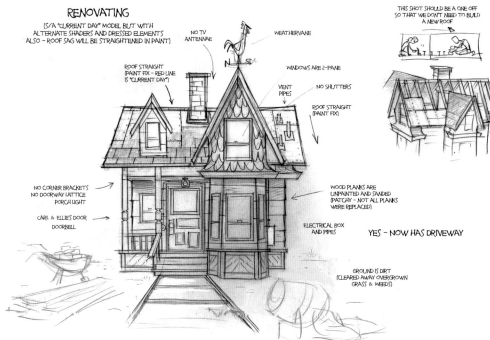

THIS SHOT SHOULD BE A ONE OFF
SO THAT WE DON'T NEED TO BUILD
A NEW ROOF

NO TV
ANTENNAE

WEATHERVANE

ROOF STRAIGHT
(PAINT FIX – RED LINE
IS "CURRENT DAY")

WINDOWS ARE 2-PANE

VENT
PIPES

NO SHUTTERS

ROOF STRAIGHT
(PAINT FIX)

NO CORNER BRACKETS
NO DOORWAY LATTICE
PORCH LIGHT

CARL & ELLIE'S DOOR
DOORBELL

WOOD PLANKS ARE
UNPAINTED AND SANDED
(PATCHY – NOT ALL PLANKS
WERE REPLACED)

ELECTRICAL BOX
AND PIPES

YES – NOW HAS DRIVEWAY

GROUND IS DIRT
(CLEARED AWAY OVERGROWN
GRASS & WEEDS)

HOUSE GOES UP

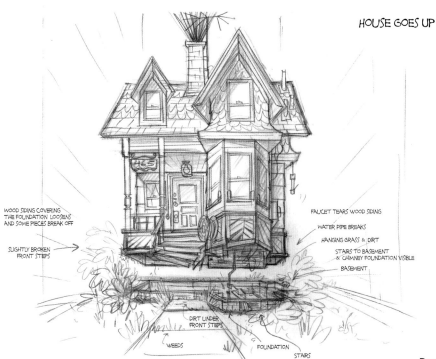

WOOD SIDING COVERING
THE FOUNDATION LOOSENS
AND SOME PIECES BREAK OFF

SLIGHTLY BROKEN
FRONT STEPS

DIRT UNDER
FRONT STEPS

WEEDS

FOUNDATION
STAIRS

FAUCET TEARS WOOD SIDING

WATER PIPE BREAKS

HANGING GRASS & DIRT

STAIRS TO BASEMENT
& CHIMNEY FOUNDATION VISIBLE

BASEMENT

"One of the art motifs for the house was the use of arrow shapes for the gables. The house was based on a box, a cube. But that's a pretty even shape, so when I created early versions of the house, some were squat and some were a little taller. One theory was that Carl is stuck on the ground, so the house could be squat to reflect that. Since the movie was about him going up, moving on in his life, a vertical house just felt more charming."

— Don Shank, environment designer

DON SHANK | pencil | 2007

"Carl's house was a challenge because we wanted the outside of the house to look very small, but then the inside had no room for the action."

— John Halstead, sets supervisor

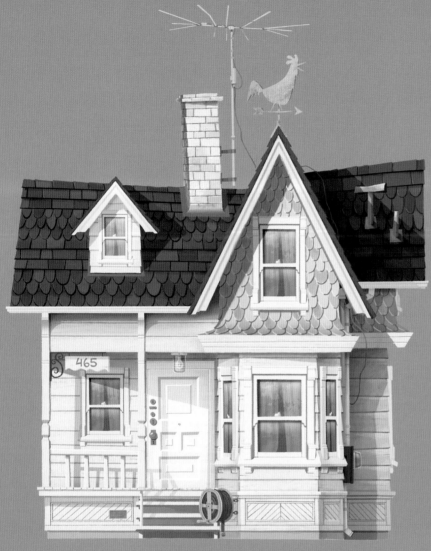

DON SHANK | digital | 2007

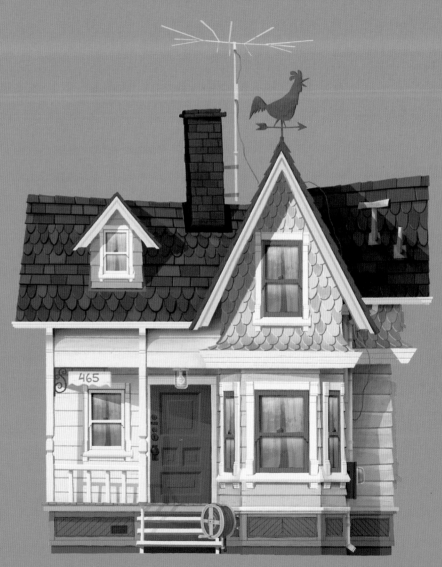

BRYN IMAGIRE | digital | 2007

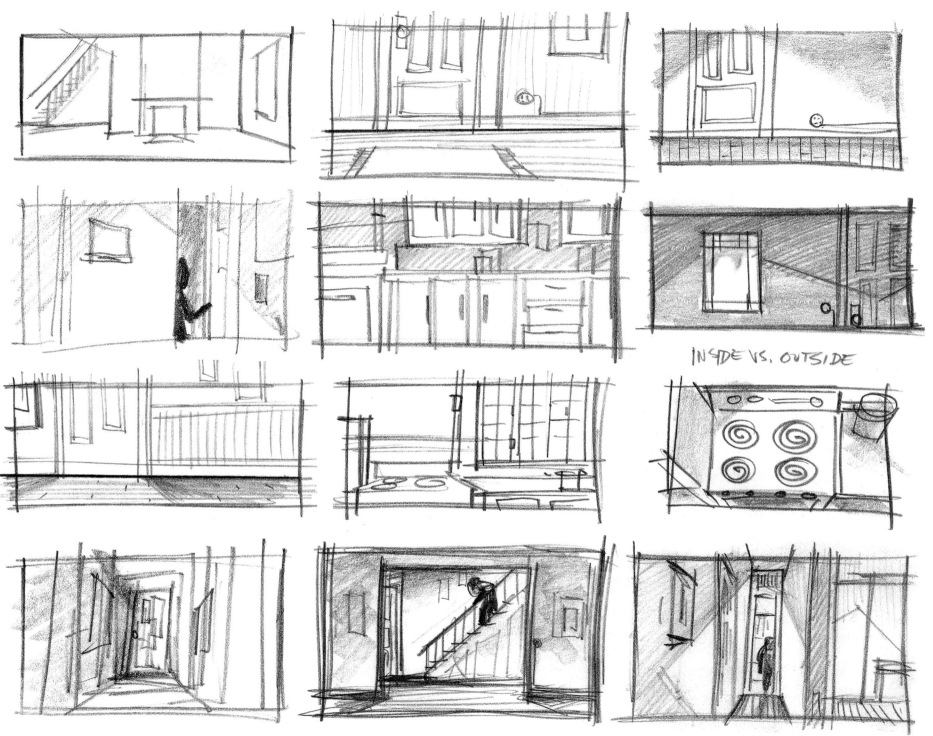

INSIDE VS. OUTSIDE

DON SHANK | pencil | 2007

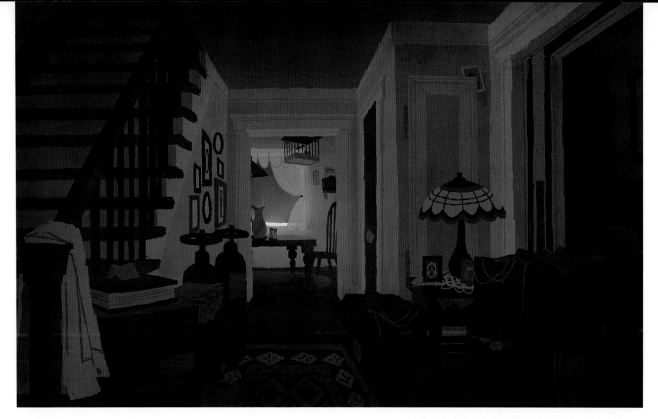

DANIEL ARRIAGA | digital | 2007

"We made Carl's house look like it had the charm of a miniature set. But we cheated the scale quite a bit, so the interior we designed wouldn't really fit inside the house. That seemed like it would be okay, but when it came time to go into layout and production, that cheat was too much to deal with. It limited some of the shots we could do because you couldn't fly the camera by the window and still see the living room inside. So I worked with the modeler, Suzanne Slatcher, to reproportion the house drastically to fit this interior."

— *Don Shank, environment designer*

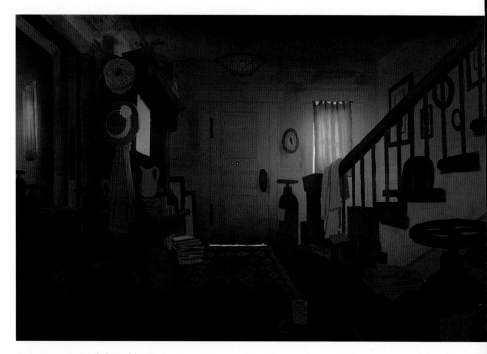

DANIEL ARRIAGA | digital | 2007

"Pete wanted the house to feel claustrophobic because Carl doesn't ever leave it, and his world has become very small. But then for the tepui and Muntz's lair, the scale had to feel grand."

— *Bryn Imagire, shading art director*

DANIEL ARRIAGA | digital | 2007

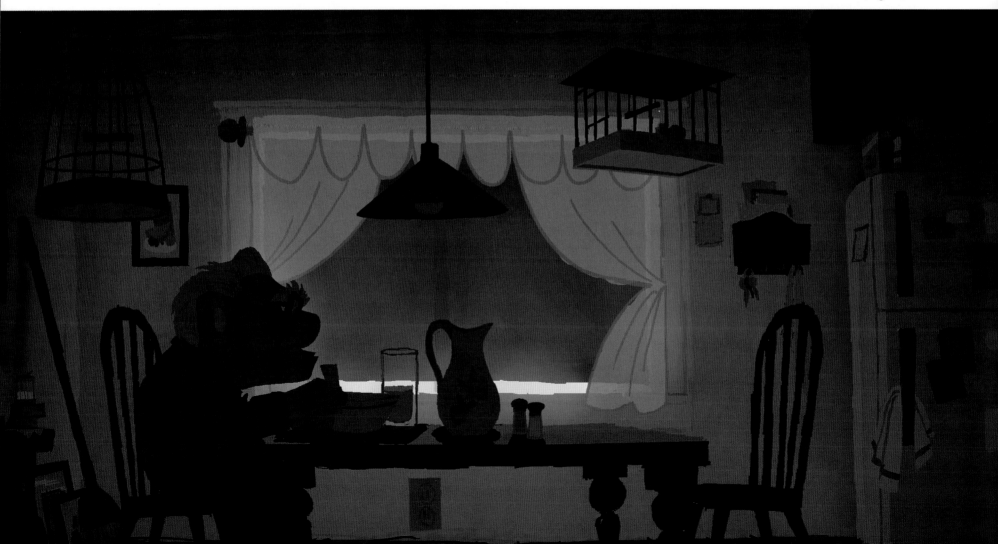

Urban Sprawl

LOU ROMANO/DON SHANK | digital | 2006

78

"There was a newness to the city, where Carl's house would be older. The city was more plasticlike, no charm to it. On Carl's particular block there were no plants. It's just dead there. Carl's house sits on a cartoonish square of green turf, but the surroundings are all mud and rubble, with no plants."

— Don Shank, designer

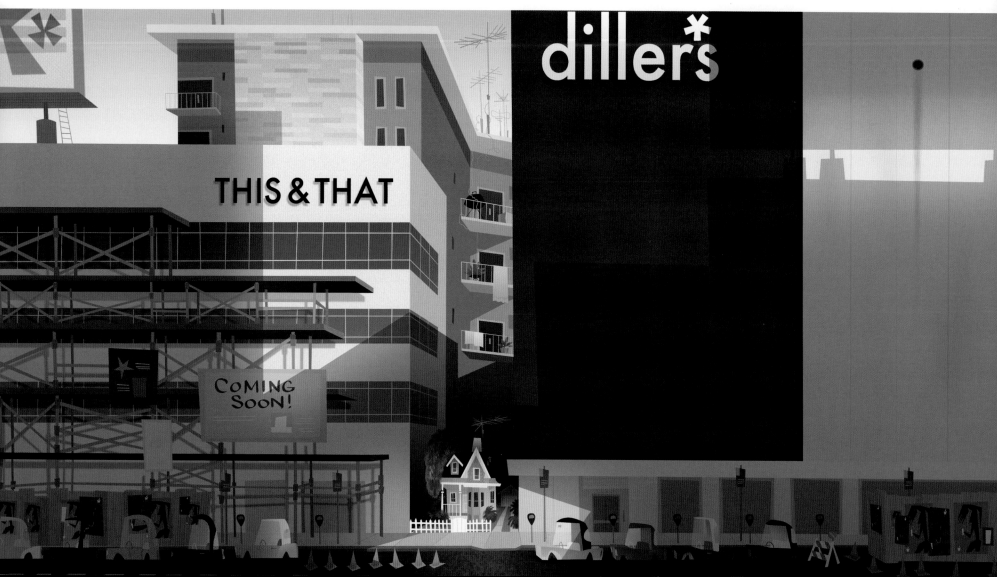

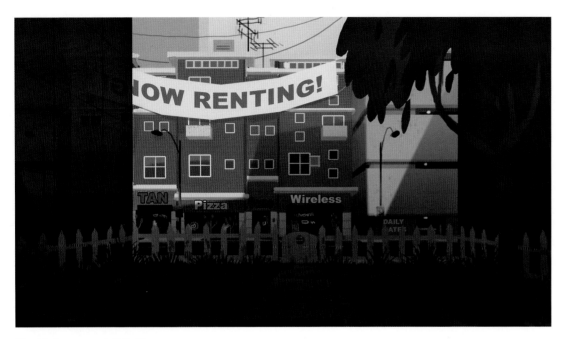

Nat McLaughlin | digital | 2007

"It took three weeks to nail down the proportions of Carl's city, which buildings would be under what state of construction, and how tall they would be. The surrounding area is under construction, so it was like a girder and panel set. I was able to design one girder and then show how they connect, then make blueprints and let the modeler assemble all the pieces like an Erector set."

— Don Shank, designer

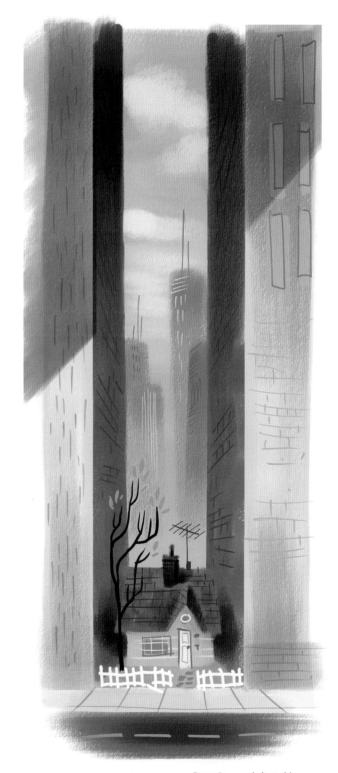

Don Shank | digital | 2004

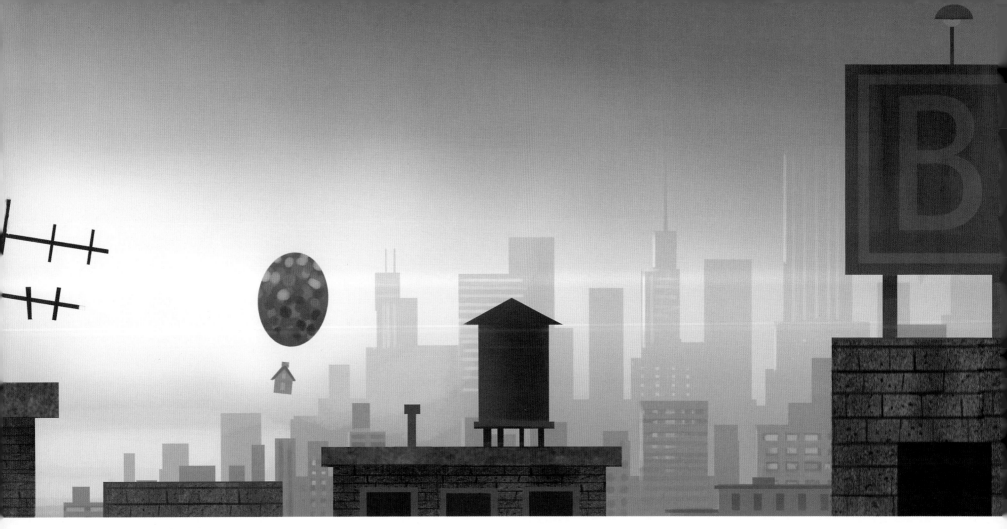

NAT McLAUGHLIN | digital | 2006

"How believable is a house being floated by a balloon if it's more realistic? Your brain starts wondering, 'Really, how many balloons is it going to take to lift that house?' But if you caricature the fantasy, you can believe it more."

— Ricky Nierva, production designer

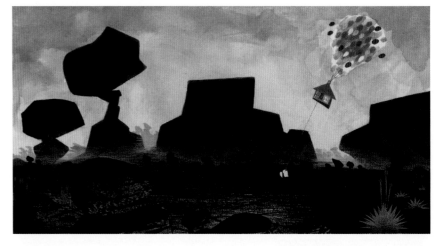

RICKY NIERVA | gouache | 2006

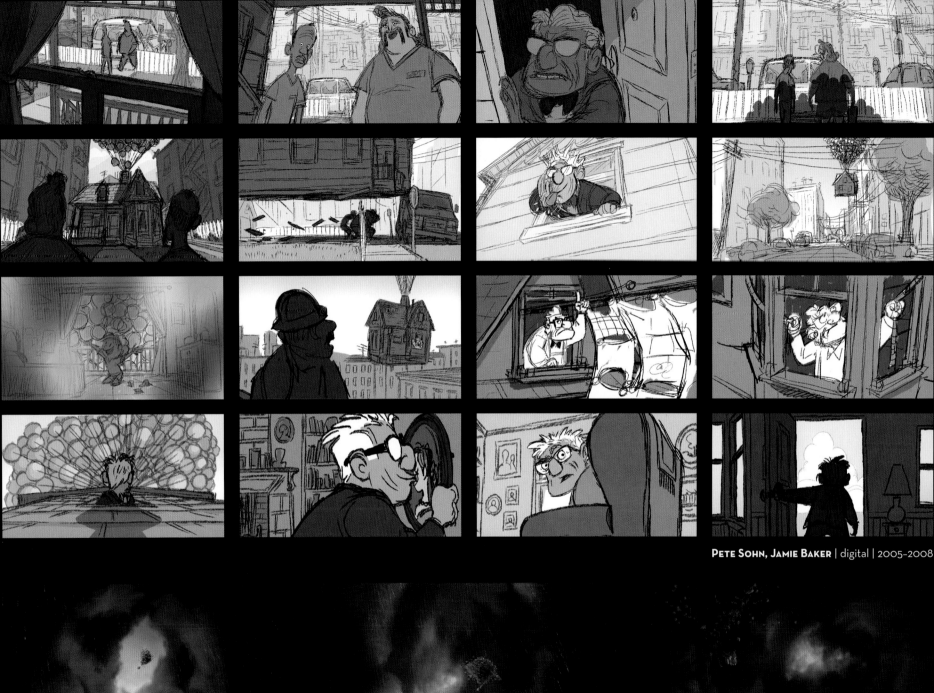

Color Script

While Ellie is alive, our color palette is heavily saturated. She brings color into Carl's life. When she's gone, the palette is desaturated to shades of gray. When Carl blows up the balloons to begin his journey, we bring back the memory of Ellie through those saturated, beautiful colors.

Generally, we show Carl in the dark while Russell is in the light.

Russell brings all of Ellie's color back into Carl's world. Any time we have life or movement forward, we use color saturation. But when there is impending doom, we almost go to black and white."

— Ricky Nierva, production designer

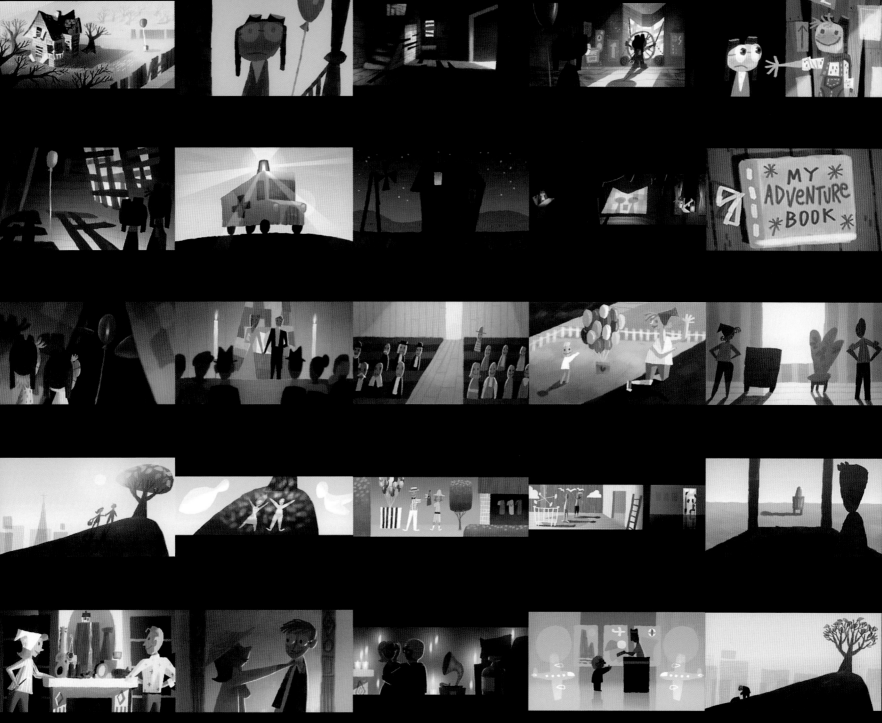

LOU ROMANO | digital | 2008

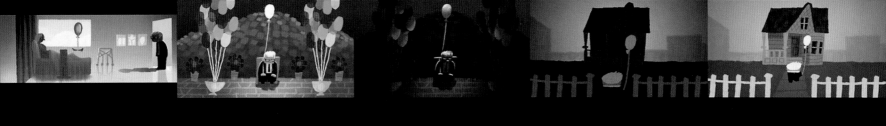

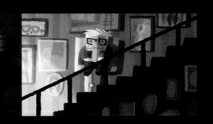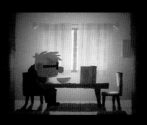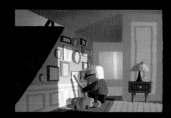

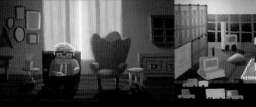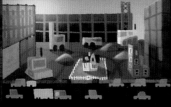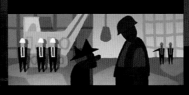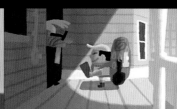

"Lou Romano created the color script, which was very detailed, and then we went back for the lighting studies. We were trying to capture the emotional feeling that Lou put into the color script.

Besides the shape language we have going, there's a very strong use of lighting and color saturation treatments for different sequences in trying to evoke a mood. We saved certain lighting effects for the climax and then carefully built up to that point.

Russell, when he comes on the scene, brings some color and saturation to Carl's drab, shut-in world. And Ellie has the same effect—of bringing color to Carl's world."

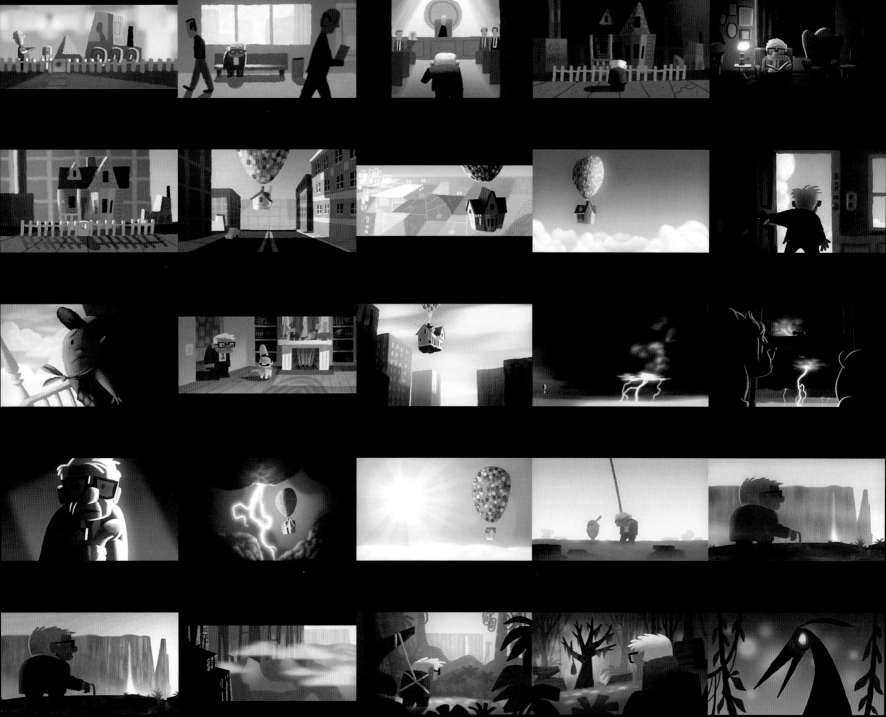

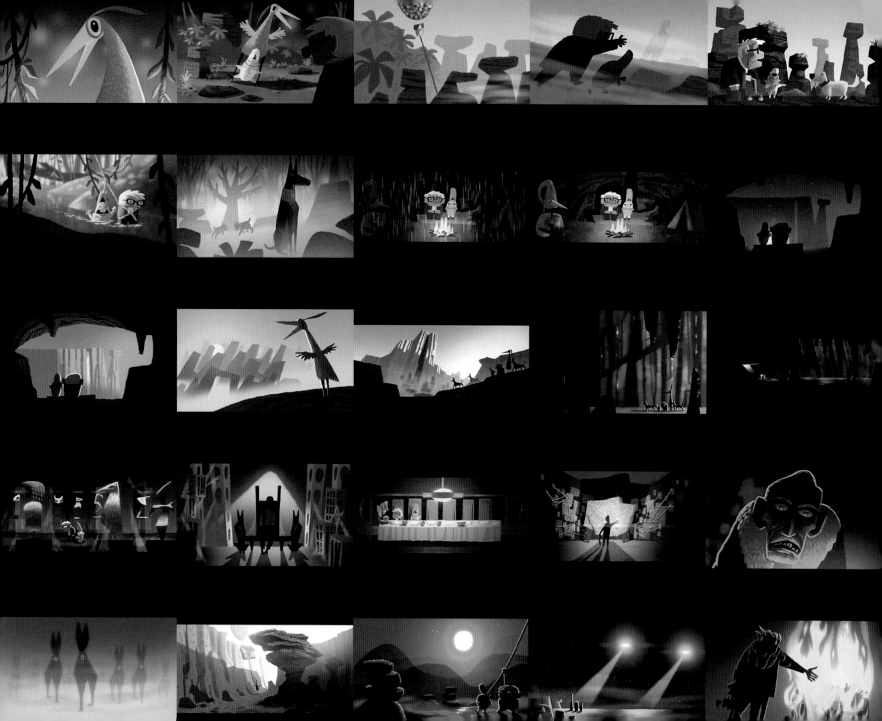

flashes of life and color."

– Lou Romano, designer

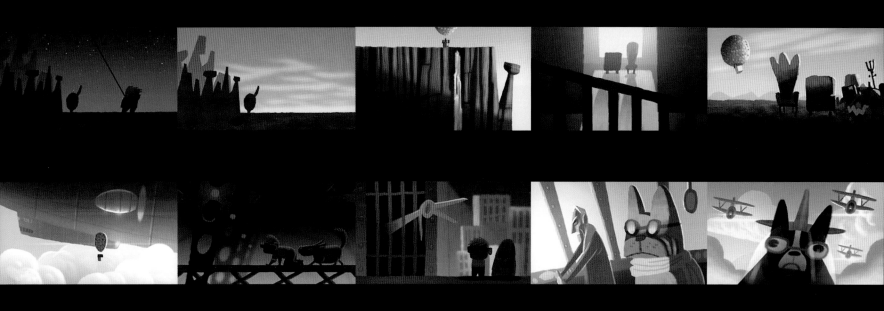

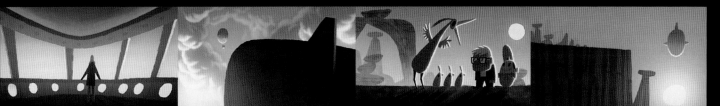

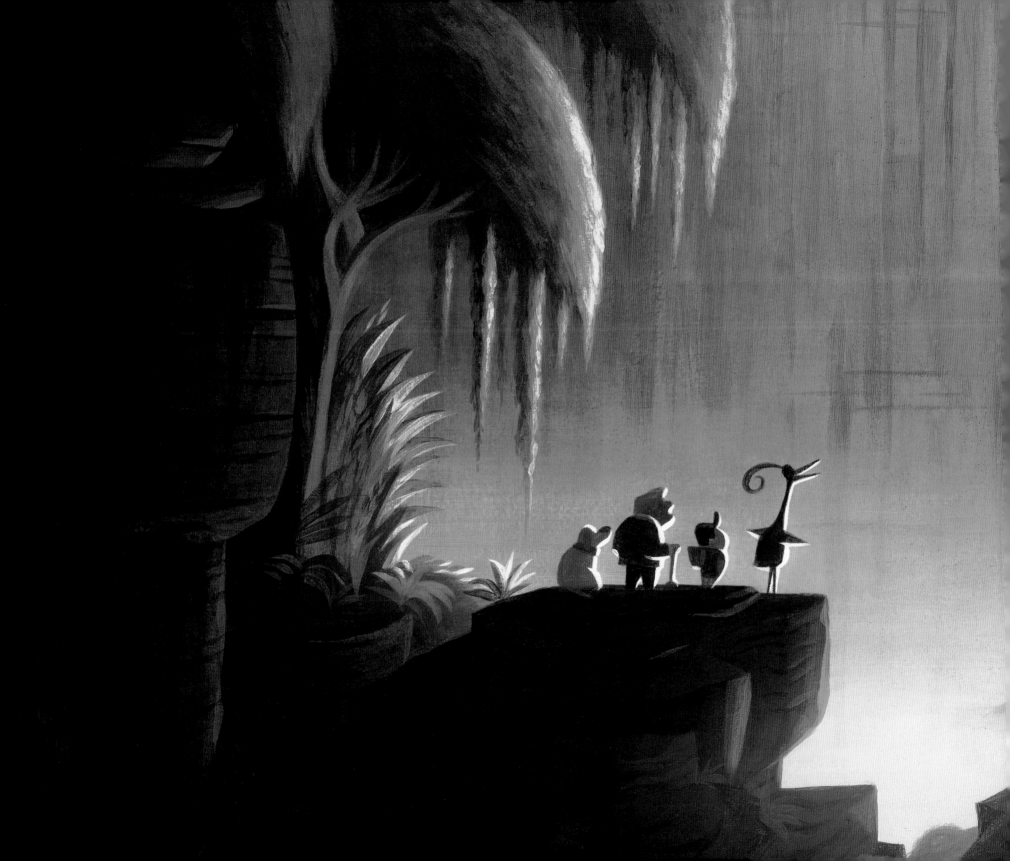

Chapter Three

ADVENTURE
IS OUT THERE!

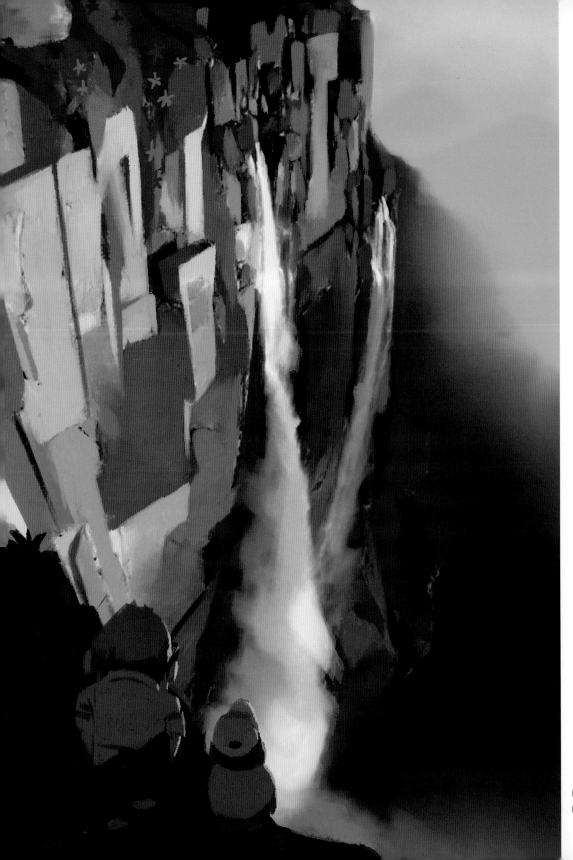

"THE *TEPUI* IS A ONE-MILE-HIGH TABLETOP mountain found in the rain forest of South America," recites Ricky Nierva, introducing us to one of Mother Nature's greatest secrets.

Tepui translates as "house of the gods" in the language of the Pemon Indians. Tepuis are uniquely singular, flat-top mountains, fiercely jutting up from the rain forests of the Guyana highlands. Among them, Mount Roraima, located at the border of Venezuela, Guyana, and Brazil, is the most famous and most explored of the tepuis. It rises more than nine thousand feet above sea level. Roraima is pocked with craters and canyons that form a treacherous natural labyrinth, while Angel Falls, the world's tallest waterfall, offers beauty along with the danger.

The tepuis are such a primeval oddity that descriptions by early explorers have sparked imaginations from the Victorian era to today. The mountains even inspired Sir Arthur Conan Doyle to pen his classic novel *The Lost World,* in which savage, prehistoric creatures still roam the Earth.

A television documentary brought these monoliths to the attention of Pete Docter. He immediately envisioned the region as the perfect setting for his new fantasy story. "We went down there doing research for this film. There are about 120 or so of these mountains and most of them have never been touched by humans because they're so remote, so inaccessible. It's kind of like the last adventure, the last frontier."

(Left) **DANIEL ARRIAGA** | digital | 2007
(Previous spread) **LOU ROMANO, DON SHANK** | gouache | 2005

> "For a fairyland it was—the most wonderful
> that the imagination of man could conceive."
> — Sir Arthur Conan Doyle,
> The Lost World

Before long, a brave troop of Northern California artists journeyed across the continent to study this Never Land on Earth. A proper expedition needs a proper guide, so Pixar sought out one of the foremost experts on the tepuis to serve as their own private Indiana Jones: Adrian Warren, the great British filmmaker, author, and explorer. The treasure seekers were about to embark on a quest for inspiration that would take them far away from the comforts of civilization. Were they up to the challenge?

"From minute one, it was truly an adventure. Every now and then, I'd just look around and we'd be in some twenty-foot canoe going down rapids with giant rocks overhead and I'd think, 'Wow. Are we really doing this?'" recalls Bob Peterson, still wide-eyed at the memory of their trek.

"We had to take planes, then jeeps down dirt roads and then a helicopter, then go another ten miles and hike from there. It felt like somewhere people had never been before. I don't know if that's true, but it felt that way," recounts production manager Mark Nielsen. Though Roraima had a ramp to accommodate hiking up to the plateau, its sister tepui, Kukenon, was accessible only by helicopter. "It's much more rugged, more remote than Roraima. There are no people on top because there is no real way to climb up."

"On top of the second tepui, this time scaled with the help of a helicopter, we asked the guide, 'How many people have been here? Thousands or hundreds, maybe?' and he said, 'No, no, *dozens*—in history—have been up here,'" recalls Docter in wonderment. "As we were walking, we were conscious that 'Right here where I'm stepping, there has probably never been another human foot.' You can't say that in California."

The artists took their time on the hike to Roraima, as they used cameras, paints, and pens to record the wonders of nature's own design.

"We climbed out to these precipices on the edge of these tepuis, looking straight down two thousand feet from these vertical cliffs. It was otherworldly. I've never been anywhere in the world that looked remotely like that," says Nielsen, savoring the memory.

For the crew of cartoonists, the physical challenges of the hike were often as breathtaking as the sights. "I was huffing and puffing and at times felt like I was a senior trying to traverse this harsh landscape," admits Peterson. "But wonder and adventure was all around. What a great setting for Carl's journey."

"The tepui was a lot bigger than I thought it would be," reports Bryn Imagire. "I imagined that you'd be able to see from one end to the other, but the landscape is so varied that it just looks huge. It's gigantic. It would take forever to walk from one end to the other."

The weather on the tepui changes constantly, from bright sunlight to pouring rain, as the clouds blow past the mountaintop. Such extreme conditions create a varied terrain. The materials are more rugged. Imagire found plants with leaves like pieces of thick plastic. "These are not like the frilly kinds of plants we have. I think that's because the weather is so harsh up there, plants have to be pretty tough and retain a lot of their own moisture."

"It was amazingly alien," marvels Nat McLaughlin, "like the Grand Canyon, but in the middle of a rain forest and very primitive. At the bottom, you had your basic rain forest with big trees, ferns, and jungle plants. But up at the top, there was a totally different ecosystem—a hothouse for all kinds of weird, primitive-looking plants. Nothing grows very tall there. It was all short and stubby."

It was clear to Docter that he had found Carl's fantasyland. "It was the closest I've ever felt to being on another planet. It's so isolated, so remote, so unlike anything that you've seen elsewhere—the rock shapes, the plants. I kept pointing out rock formations to Ricky, saying, 'I don't believe any of that.' If you put that image up on the computer, I would say, 'There's no way that rock can actually stand, supported by this thin little spindle underneath.' But there it was, in real life, right in front of us."

Our travelers returned home from their adventures to discover a new kind of problem.

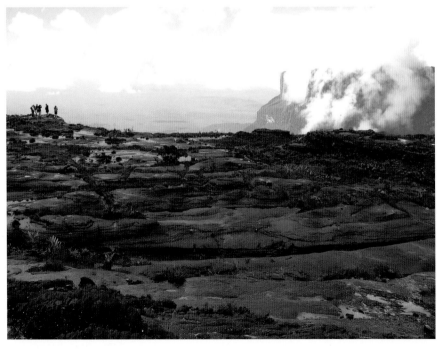

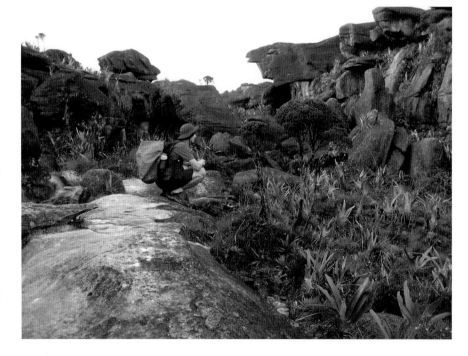

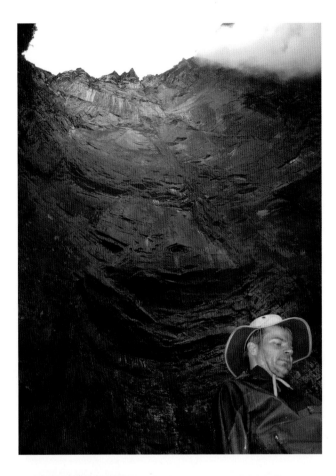
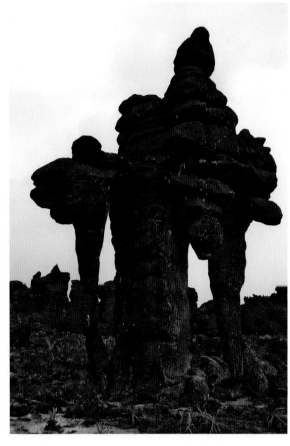

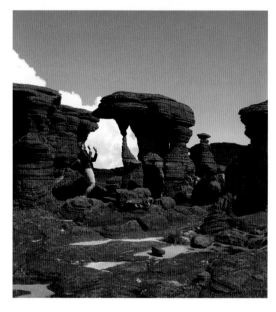
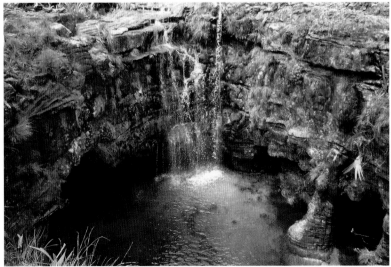
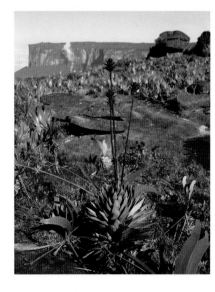

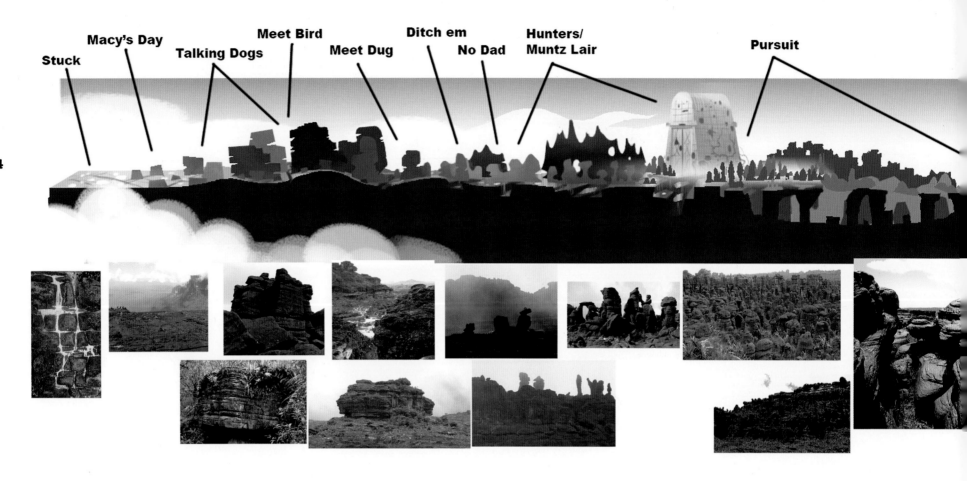

Stuck Macy's Day Talking Dogs Meet Bird Meet Dug Ditch em No Dad Hunters/ Muntz Lair Pursuit

The filmmakers wanted their CGI environment to appear believable, to convey a sense of real, physical danger for the characters. But, while examining the wealth of research material, Rivera and his team found that the shapes, topography, and textures of the real tepui environment were too unreal. "It looks like a trip to the moon or Never Land or something," says Rivera. "It looks fake."

Docter set the challenge for art direction: "How do you take such a fantastic place, that is *so* fantastic and unfamiliar to people, and make it believable?"

The art department looked to their past challenges for solutions to their riddle. Imagire found that, when you are creating a balance between fantasy and realism, there are some things you just can't (or shouldn't) make up. "With the organic locations, the tepui and the rocks, we are going for greater realism. We realized on *The Incredibles* that you can't stylize certain natural elements too much, or else you don't believe it. Everyone instinctively knows what a rock looks like, so if the scale is off, you don't buy that."

"The early inspiration from Pete was to make the tepui look like a land stuck in time to reflect Carl's personal issues," McLaughlin says. "We animated a little piece of test footage with Carl and Russell hiking through the jungle. The primary directive was to make it look primitive, alien, but lush at the same time. The jungle is one of the most difficult locations in the film to reproduce, with the depth and density required. We had to make it look like a jungle and not just a bunch of plants." That successful test pointed the way through the design jungle, but there was much yet to explore.

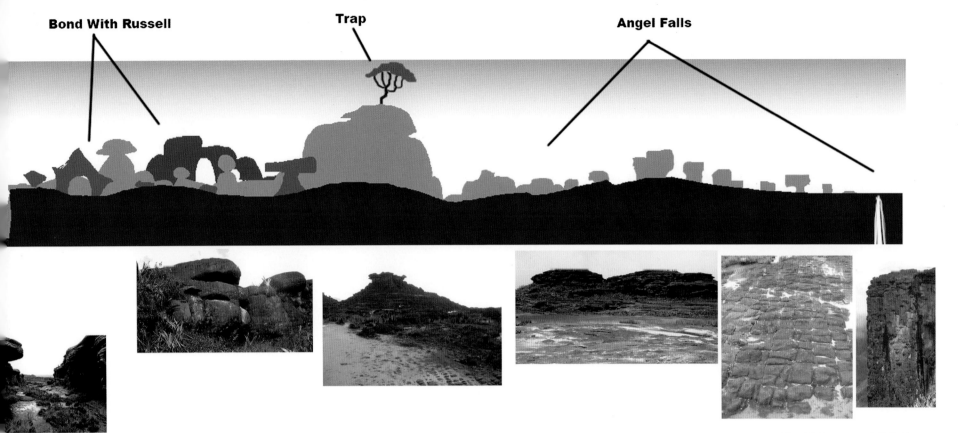

Bond With Russell

Trap

Angel Falls

NAT MCLAUGHLIN | digital | 2007

The Venezuelan rain forest hides more than strange rock formations and verdant foliage. In the story of *Up*, this is the realm of our long-lost adventurer, Charles Muntz, once the childhood hero of Carl and Ellie, but now a much darker character. It is here that Muntz has tracked a shadowy creature, never before seen by science, which hides within the tepui's labyrinth.

"The labyrinth, which is where the bird hides in our story and where her babies live, was inspired by an actual place on Roraima," recalls Nielsen. "We came right up to the very edge of this labyrinth, but

"We made a whole chart just for how the rocks are going to look throughout the film. The rocks will be squared-off when the house lands on the tepui and then, as they travel across, and as Carl's relationship with Russell changes, you are going to slowly see more rounded rocks, more circles, more softness."

— *Nat McLaughlin, designer*

we didn't go in. We had heard stories about how dangerous it is and how you could get lost so easily."

In the film, Muntz's impressive airship serves as the aged eccentric's personal gilded cage, a museum to his own outsized ego and aspirations. "With Muntz, we were trying to capture that Howard Hughes spirit of innovation and adventure," Nierva recalls of the reclusive aviator and millionaire eccentric.

The artists sought to reflect the heroic notion of early aviation in their dirigible designs. The airship is impressive, grand in scale, with a high-tech polish. Its construction would have been state of the art in 1934, so McLaughlin looked to trends of the era for reference, specifically the "streamline moderne" style. "We looked at the *China Clipper*, which was one of the first intercontinental airline services that had these big flying boats inside. We wanted a super-thirties look. The airship had to feel almost like an artifact, which Muntz himself had become."

In the shadows of the dirigible, Carl confronts this shattered reflection of his own ego. "Pete wanted a shocking reveal that Muntz, this guy that they have admired so much, was really crazy now," says Harley Jessup. "Muntz is obsessed with this bird, so he has all kinds of diagrams and feathers that he's collected over the years, tagged with the exact location of where he found them."

"Muntz is an extension of Carl—[the probable result] if Carl were allowed to do exactly as he wants, which is obsess about the past at the expense of contact with the real world or other characters," Docter explains. "He has become so obsessed by the idea of accomplishment, of bringing this bird back to civilization, that he has lost contact with everyone in society."

The discoveries Carl makes on his journey alter his perception of aspiration and achievement. He ultimately crawls out of his shell to defeat his shadow-self represented by Muntz. For Pete Docter, the visit to the tepuis encouraged a similar awakening: "That trip was life changing. It really affected me. Now I realize I want to go out and experience more of the world."

The filmmakers concentrated their efforts on transferring their impressions of the lost world to the screen so that we all might be similarly inspired by these natural wonders. "The burden of trying to pass along what I saw up there has been an adventure in itself. Not only to re-create for audiences what it actually looked like, but to re-create the *feeling* of what it looked like. That was really difficult," admits Nierva. "But I learned to enjoy the process of making a film as it goes. It's like climbing Mount Roraima. It's not about getting to the top, but enjoying that hike all the way up. And then, when we get to the top, there's still a whole new world to explore."

"And the end of all our exploring will be to arrive where we started and know the place for the first time."
—T. S. Eliot, *Four Quartets*

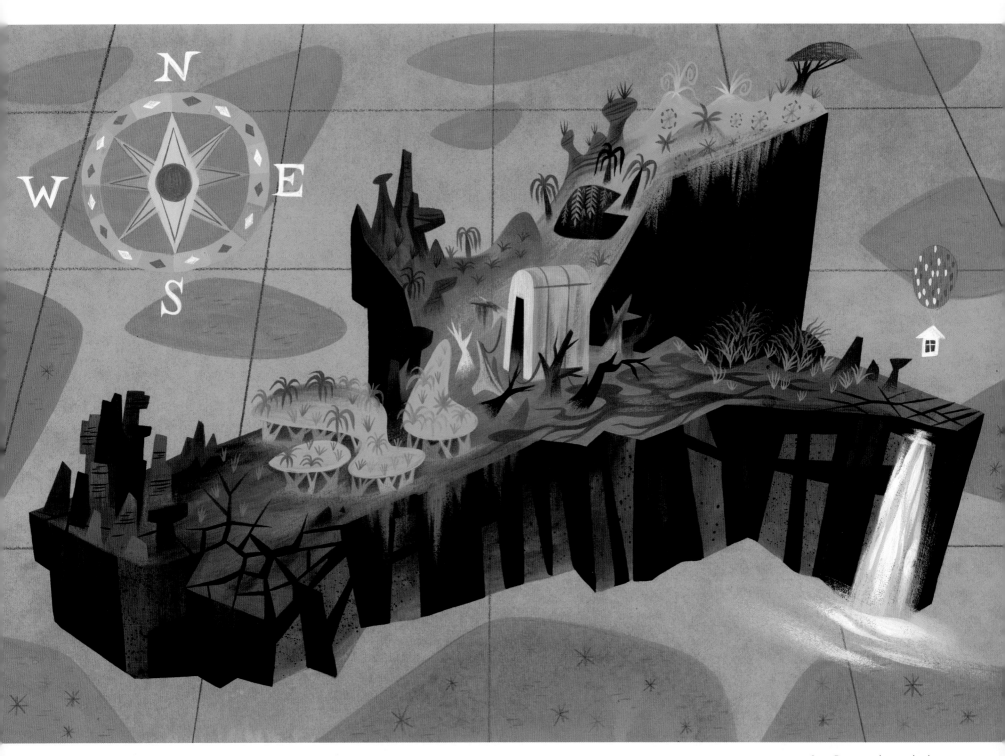

The Tepui

"There are lots of bugs on the tepui: large,
looks-like-they-could-be-man-eating bugs."
— Albert Lozano, designer

LOU ROMANO/DON SHANK | acrylic | 2005

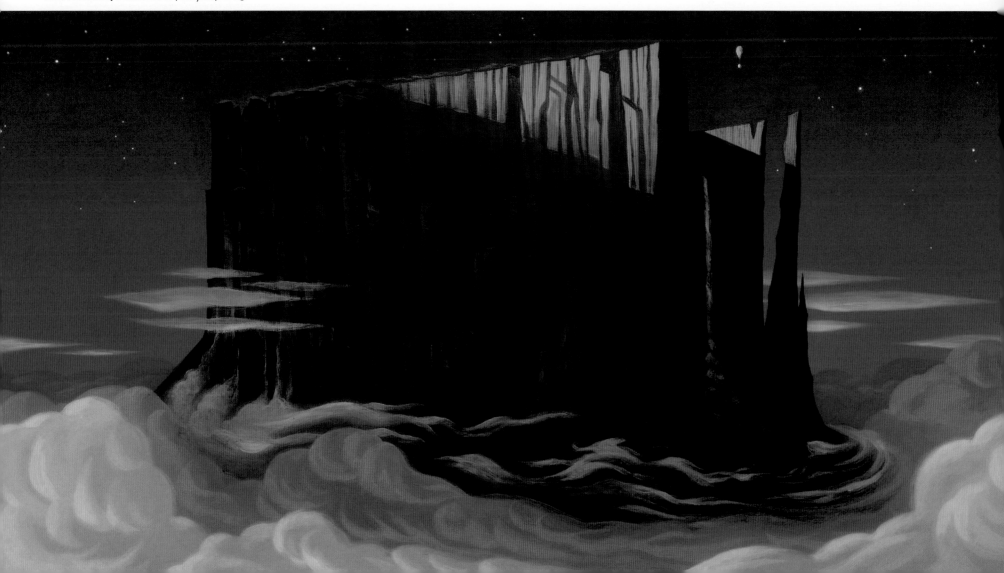

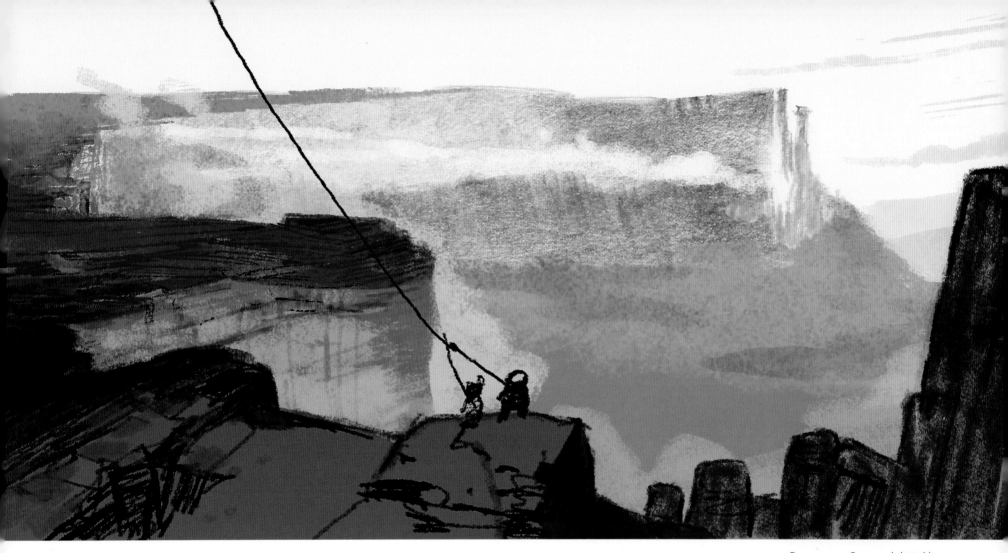

"When you are at the top of the tepui, I'd say that rock is the thing
that you notice most—in many different shades, colors, and textures.
It's all sandstone, but there is so much wetness and growth that the
rock is covered in scuzz. It gives the rocks a bluish black tint that you
can't really see from the photographs. It's a very subtle thing. Bryn
tried to simulate that look with paintbrush textures. They painted
the underlying rock with a bluish green algae."

— Nat McLaughlin, designer

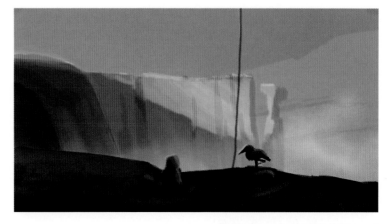

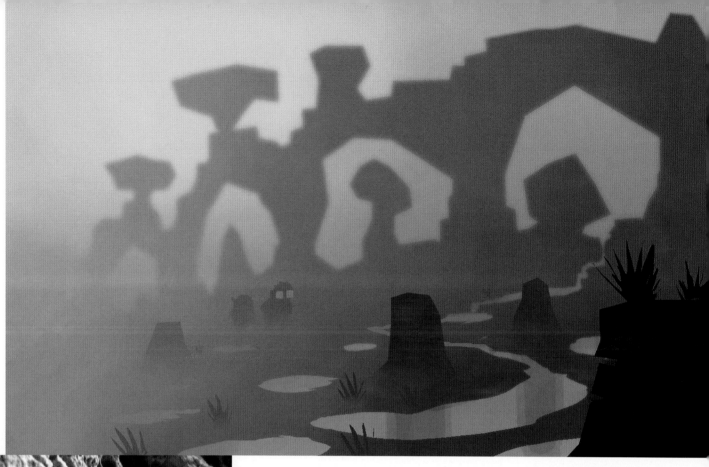

NAT McLAUGHLIN | digital | 2006

"Don Shank called the tepui rock formations modern art that was made by nature."

— Ricky Nierva, production designer

LOU ROMANO | digital | 2006

"We'd look out over the edge—and straight down—at these massive spires and hanging gardens and rocks that were shaped like faces and people. It was unbelievable."
— Bob Peterson, codirector and writer

LOU ROMANO | gouache | 2006

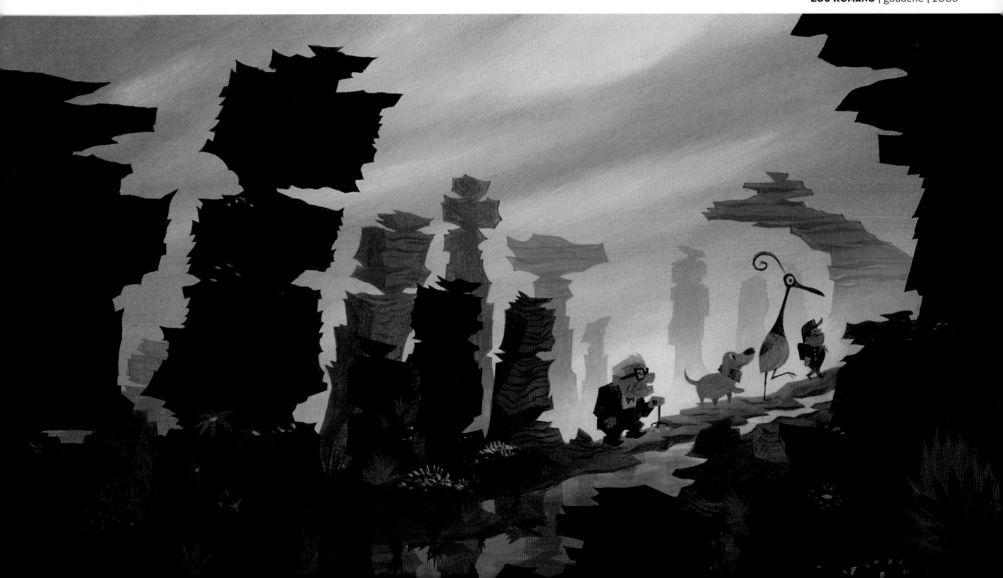

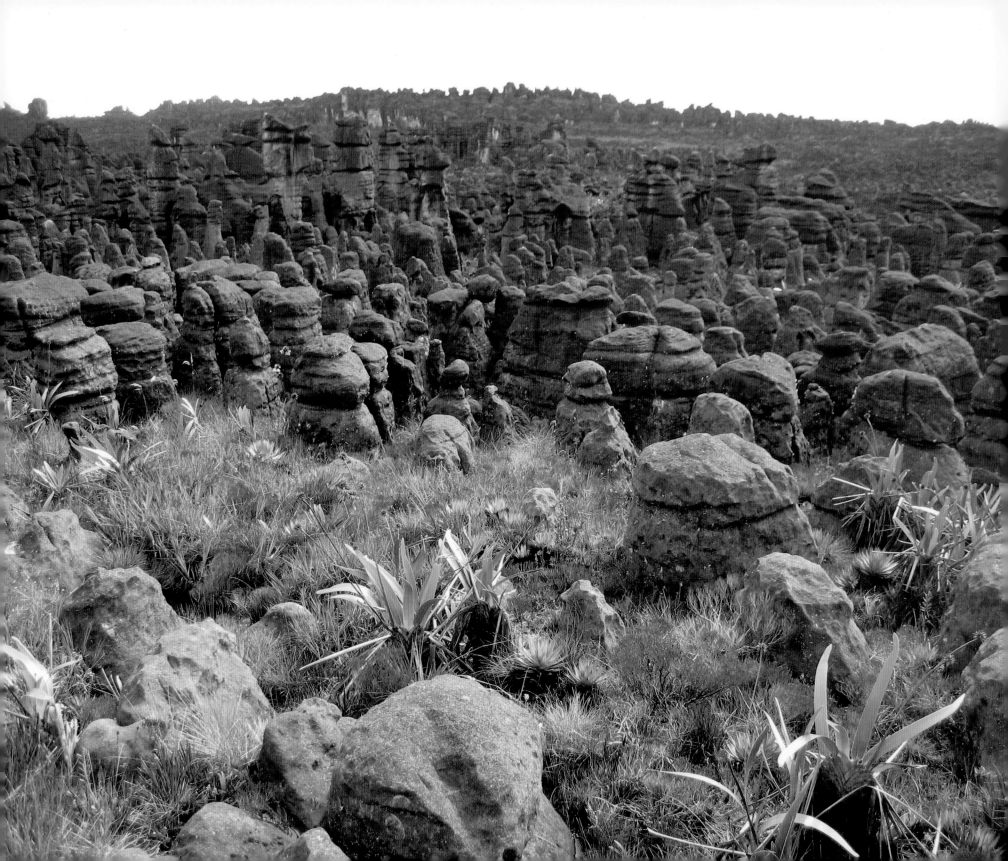

"[From what we could see] the labyrinth on Roraima had extremely bizarre rock shapes, dense pillars, columns, and arches everywhere. Hidden pits of water. It looked to be treacherous."

— Nat McLaughlin, designer

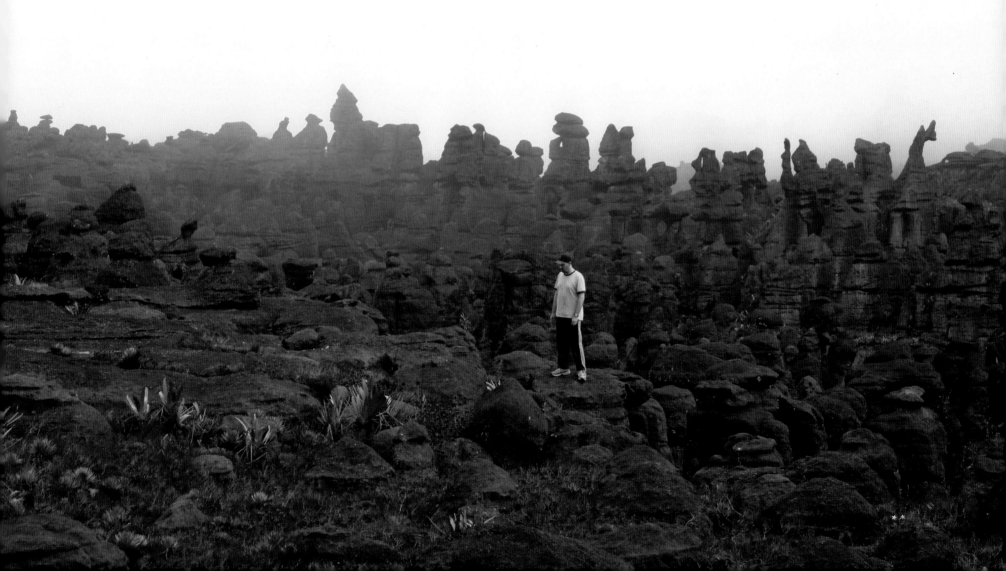

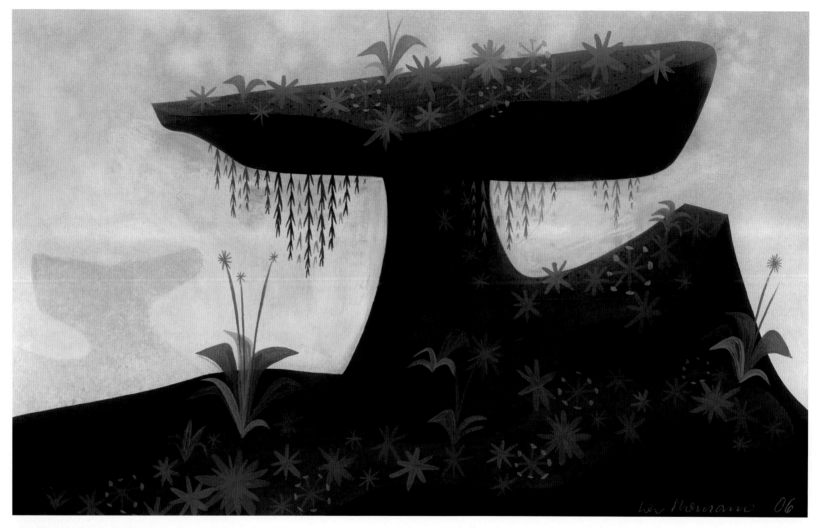

LOU ROMANO | gouache | 2006

BRYN IMAGIRE | gouache | 2006

"For our plants, there is a life cycle happening in each shot. At first, when we designed a plant, we created a clean graphic representation. But the thing that we learned in CG is that you have to add the leaves that are dying and leaves that are younger to make it look convincing. This is fascinating because, once you do that, you start observing the life cycle. You have the young bud growing, the vine that's matured and the leaf that's dying. And the dead things fall to the ground and provide matter for the next plant to grow from."

— *Ricky Nierva, production designer*

Lou Romano | gouache | 2006

Bryn Imagire | gouache | 2006

"With a lot of those plants in Venezuela, like the chiflera tree, the leaves had an interesting furry texture. The bromeliad had an interesting effect where one side was green and then the other side was red. And that's from exposure to sunlight. The plants grow so fast that the red part doesn't have time to produce chlorophyll. There's really a biological reason why it's so beautiful. The red and green contrast is very graphic and that's something Pete wanted to maintain throughout. So we used these little design details to bring those qualities in."

— *Bryn Imagire, shading art director*

105

Bryn Imagire | gouache | 2006

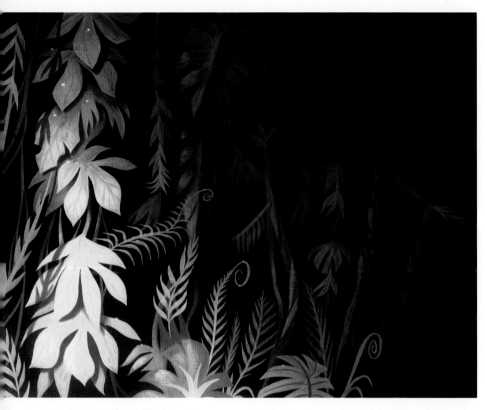

LOU ROMANO | gouache | 2006

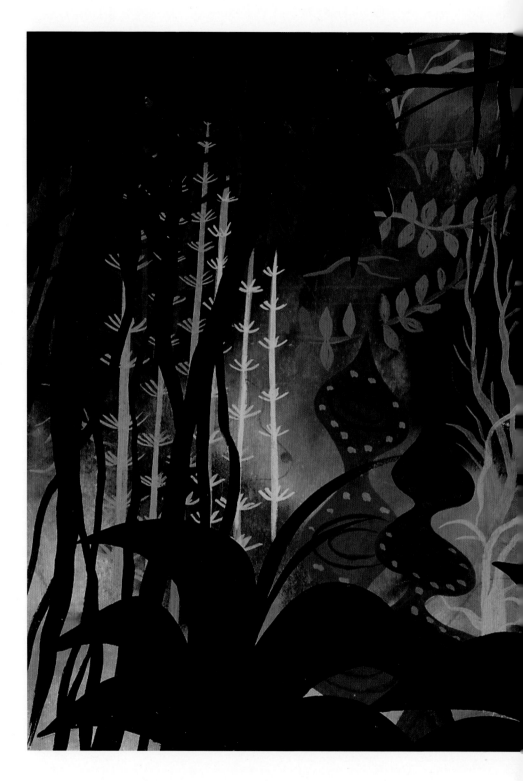

"The plants were so beautiful, we didn't have to make anything up. We'd just pick the colors, eliminate all the extraneous detail, and do simple color gradations. Then they looked beautiful. It's really easy to make plants beautiful because they are completely organic. We examine real life, then extract the essence of beauty from each one."

— Bryn Imagire, shading art director

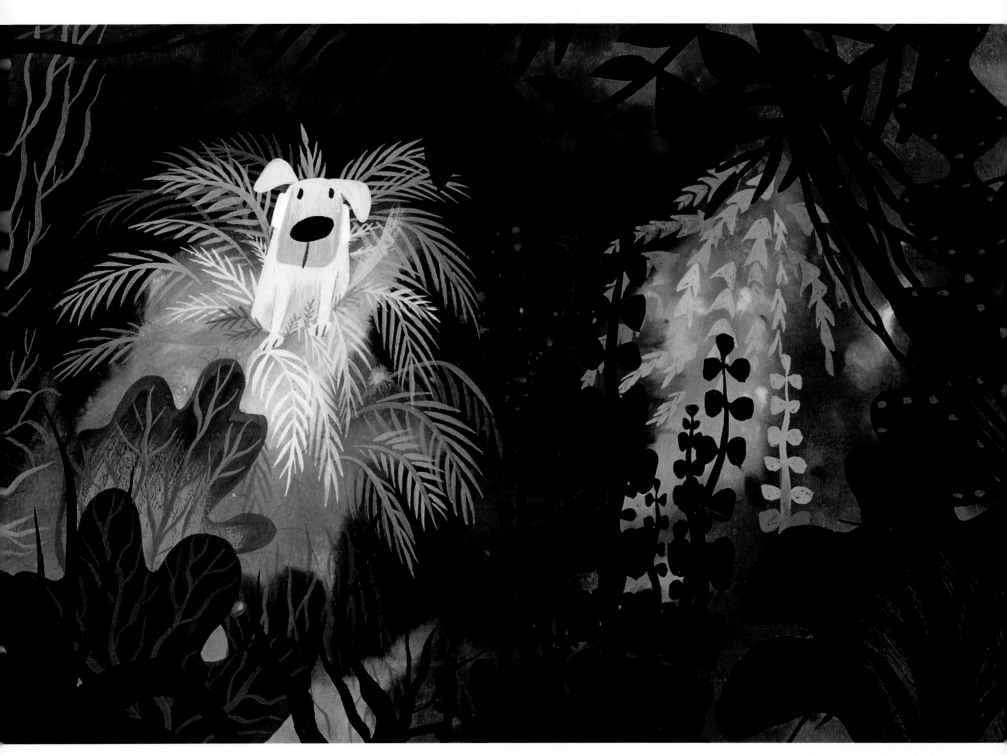

LOU ROMANO | gouache | 2006

"How hard is it for an eighty-year-old guy to be out floating around the world? It's difficult enough just to make it to the park and back if you've got bursitis and arthritis."

— *Bob Peterson, codirector and writer*

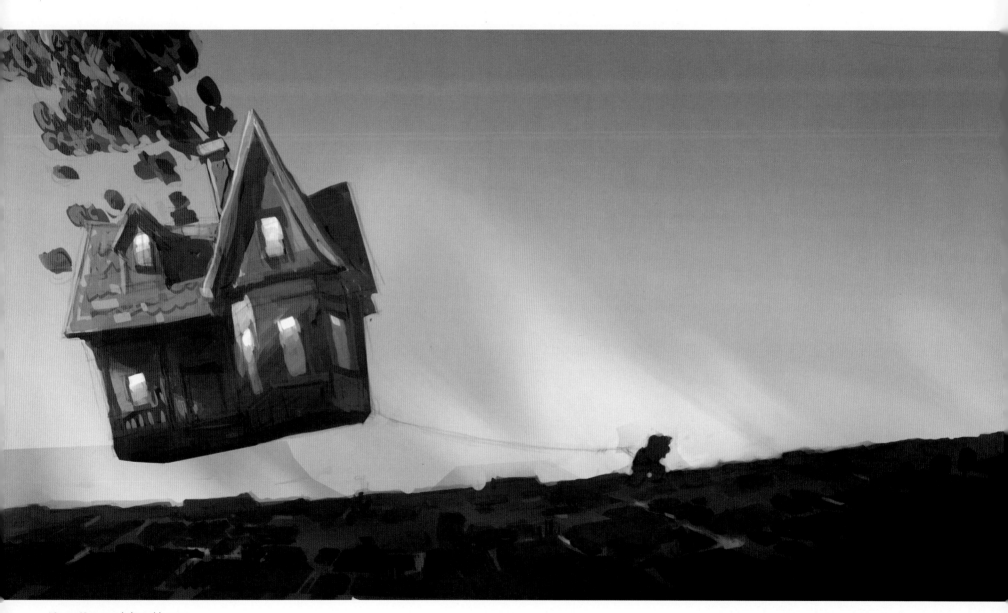

NOAH KLOCEK | digital | 2008

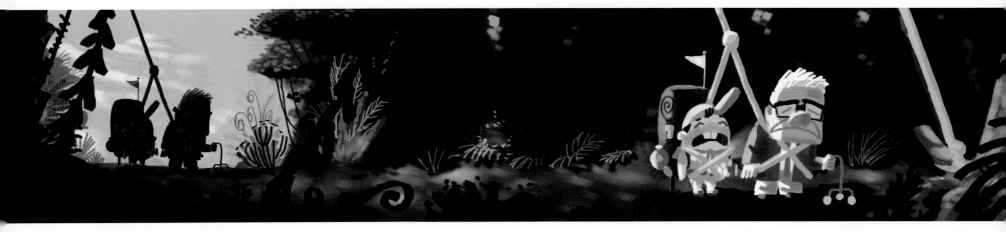

LOU ROMANO | digital | 2006

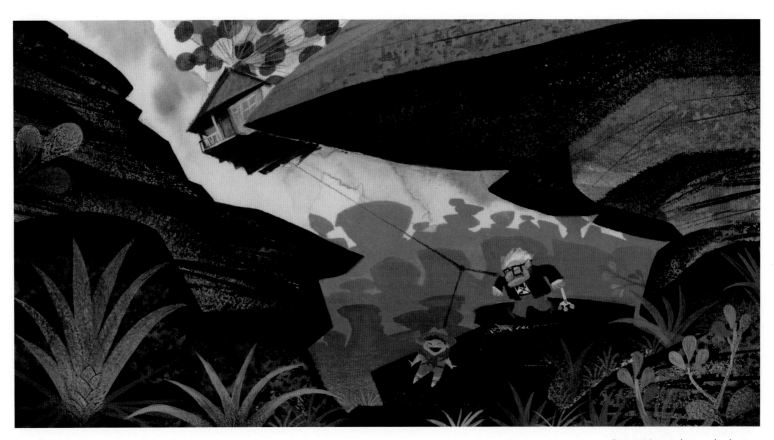

RICKY NIERVA | gouache | 2006

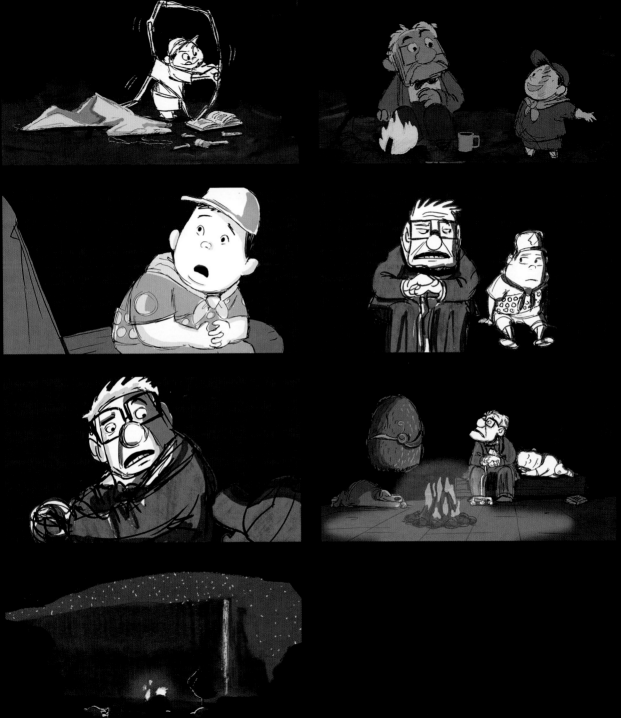

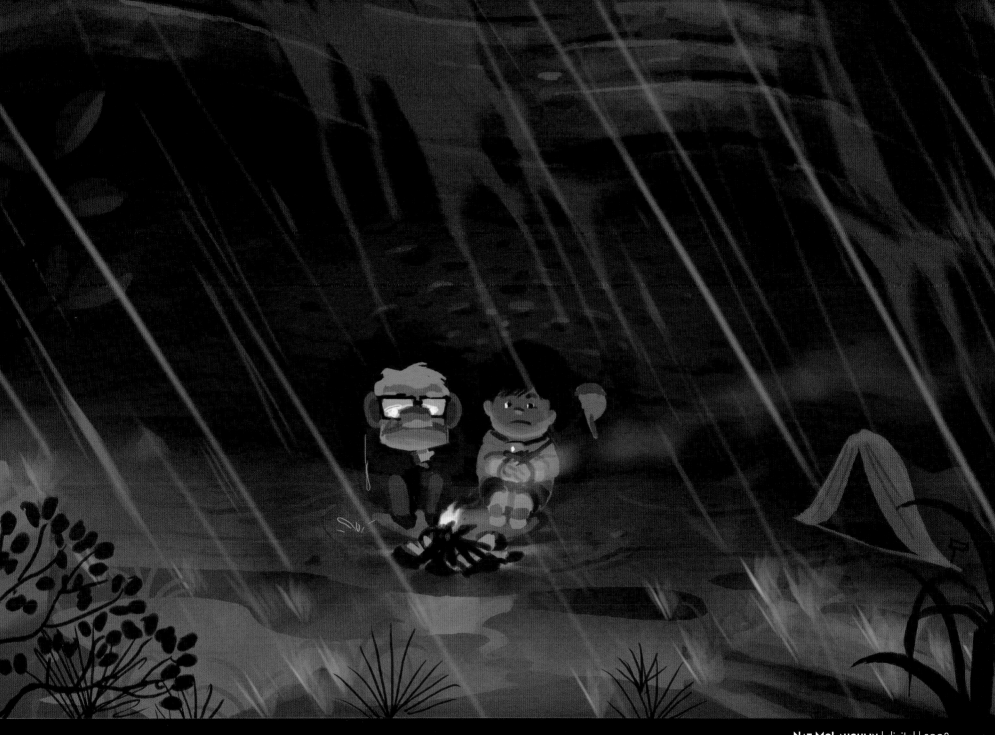

Nat McLaughlin | digital | 2008

Kevin, the Bird

"The bird character has always had this enormous potential for animation fun. She's very unpredictable, and you don't know what she is going to do. If you watch real cranes and storks, they are hilarious in that same unpredictable way."

— Pete Docter, director

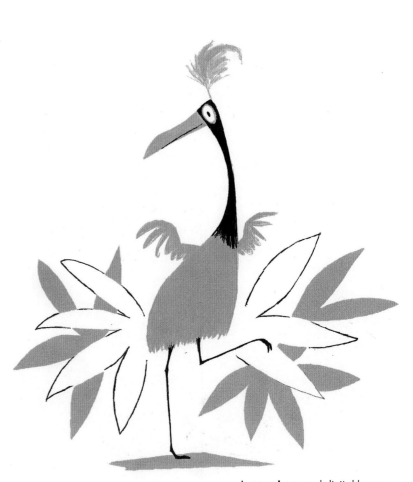

ALBERT LOZANO | digital | 2007

ALBERT LOZANO | digital | 2007

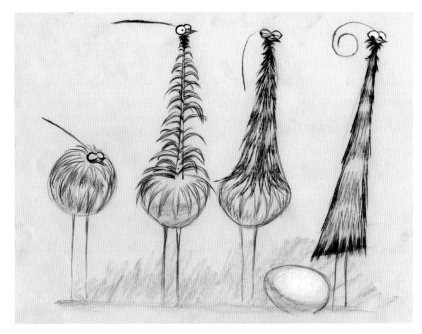

Daniel López Muñoz | digital | 2006

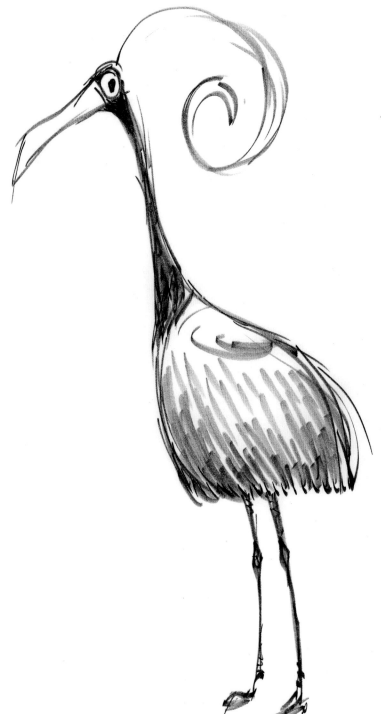

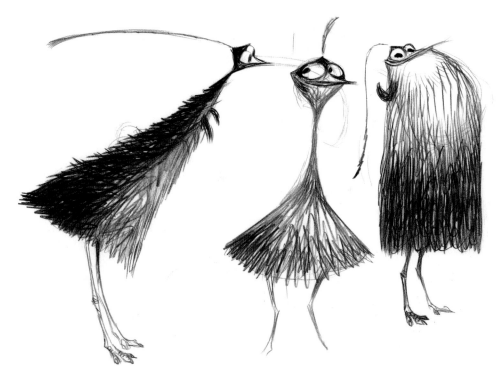

Daniel López Muñoz | digital | 2006

Ricky Nierva | pencil | 2005

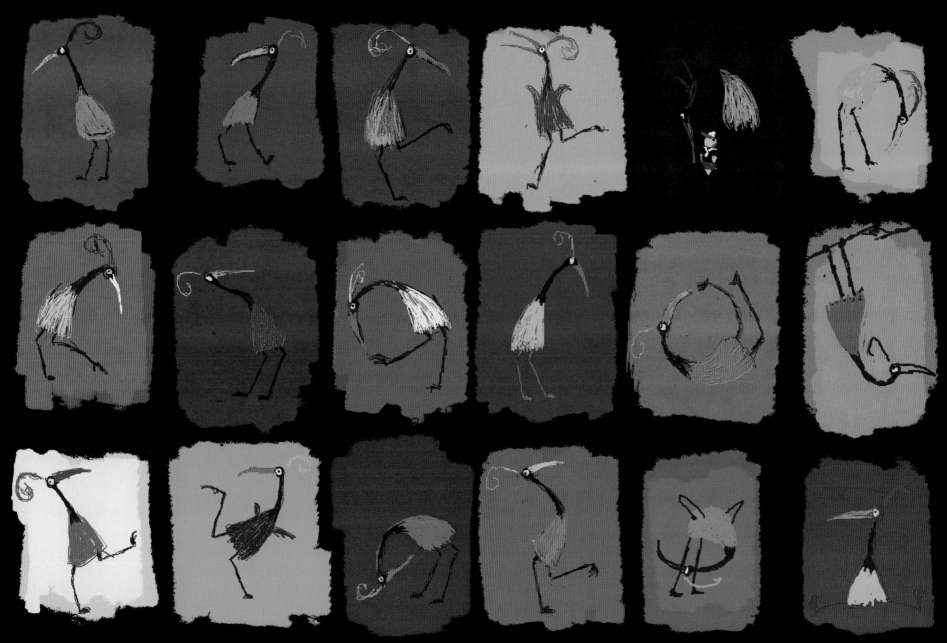

ALBERT LOZANO | digital | 2006

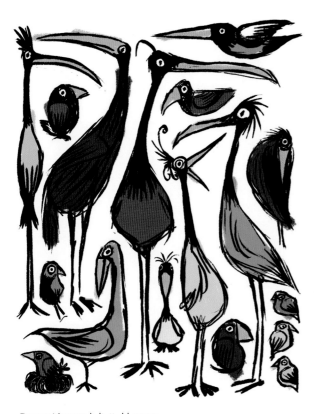

RICKY NIERVA | digital | 2005

"We did a lot of research on the large flightless birds. We looked at ostriches. We went to an ostrich farm. We actually had two ostriches brought here. They were out on the campus outside. And we visited the zoo to get a glimpse of emus, but we also studied cassowaries, which are very strange, very dangerous relatives of the emu."

— Greg Dykstra, sculptor

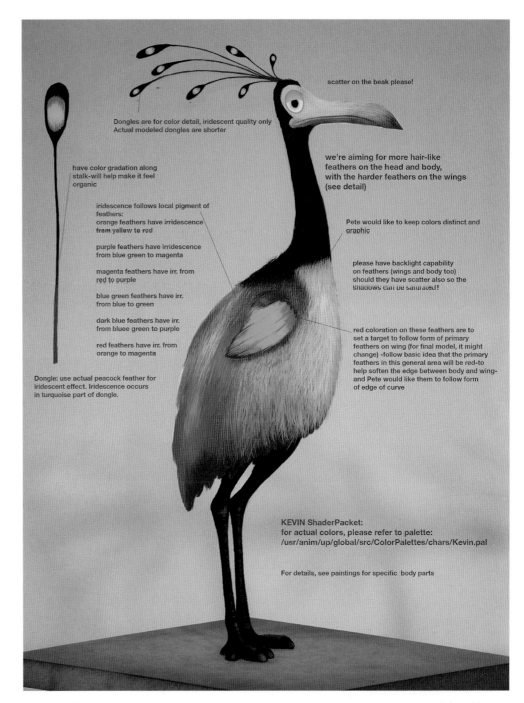

scatter on the beak please!

Dongles are for color detail, iridescent quality only
Actual modeled dongles are shorter

have color gradation along stalk-will help make it feel organic

iridescence follows local pigment of feathers:
orange feathers have irridescence from yellow to red

purple feathers have irridescence from blue green to magenta

magenta feathers have irr. from red to purple

blue green feathers have irr. from blue to green

dark blue feathers have irr. from bluee green to purple

red feathers have irr. from orange to magenta

Dongle: use actual peacock feather for iridescent effect. Iridescence occurs in turquoise part of dongle.

we're aiming for more hair-like feathers on the head and body, with the harder feathers on the wings (see detail)

Pete would like to keep colors distinct and graphic

please have backlight capability on feathers (wings and body too) should they have scatter also so the shadows can be saturated?

red coloration on these feathers are to set a target to follow form of primary feathers on wing (for final model, it might change) -follow basic idea that the primary feathers in this general area will be red-to help soften the edge between body and wing- and Pete would like them to follow form of edge of curve

KEVIN ShaderPacket:
for actual colors, please refer to palette:
/usr/anim/up/global/src/ColorPalettes/chars/Kevin.pal

For details, see paintings for specific body parts

BRYN IMAGIRE | digital | 2008

116

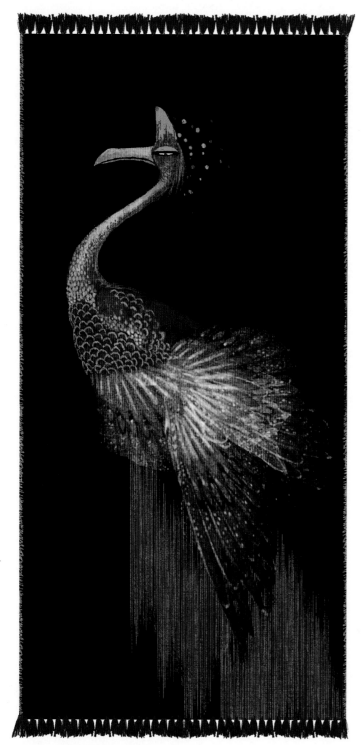

"The bird is a cipher. We liked the idea that a bird looks at you with only one eye. She is one-dimensional."
— Ronnie del Carmen, story supervisor

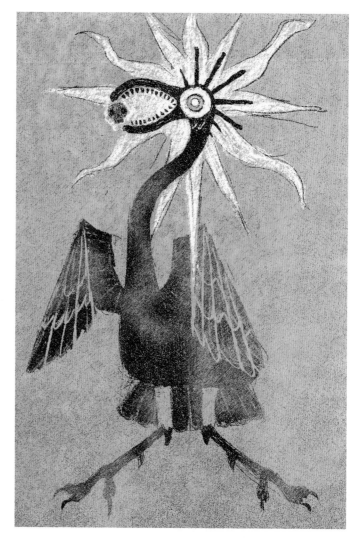

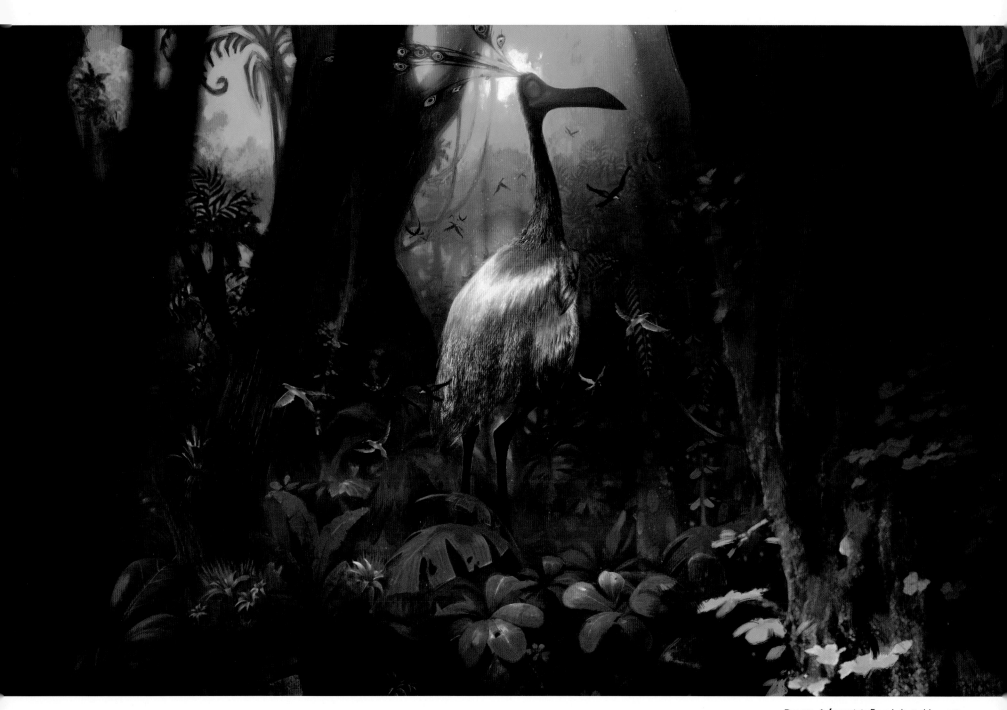

DANIEL LÓPEZ MUÑOZ | digital | 2008

Dug

"Dug is a fat dog. We always thought of him as a cross between a Labrador and a golden retriever. There was a dog on this online adoption website whose name was Buddy. We have photos of that dog and, when Pete saw him, he said instantly, 'That's Dug. That's the dog that's going to be Dug.'"

— *Albert Lozano, designer*

BOB PETERSON | marker | 2004

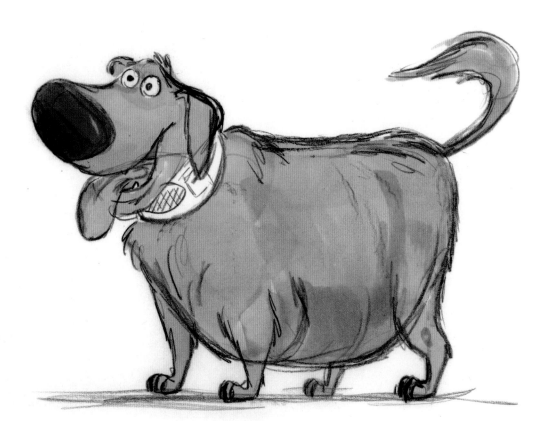

ALBERT LOZANO | pencil/digital paint | 2006

PETE DOCTER | marker | 2004

ALBERT LOZANO | pencil/digital paint | 2006

ALBERT LOZANO | pencil/digital paint | 2006

"One of the inspirations for Dug was Chris Farley. We were looking at the *Saturday Night Live* routine with Patrick Swayze where they are auditioning for Chippendales. Dug thinks he's an Alpha Dog and thinks he belongs with the rest of the pack, just like Chris Farley thought he could be a Chippendales dancer next to Patrick Swayze. We wanted to think of Chris Farley as a dog."

— Albert Lozano, designer

120

LOU ROMANO | gouache | 2006

PETE SOHN | digital | 2005

"Of course, you are meant to fall in love with Dug. Dug will be this plush, fat dog that you just instantly want to hug. So he's meant to be a quick read. You have to get right away why Russell wants this dog and loves this dog."

— Albert Lozano, designer

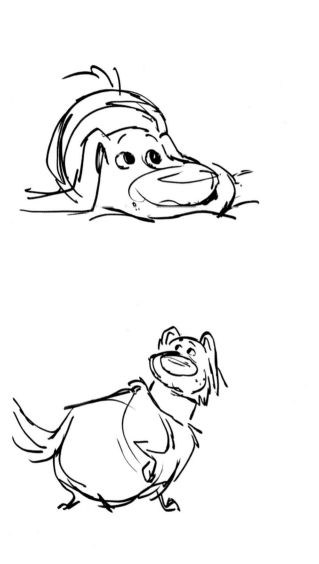

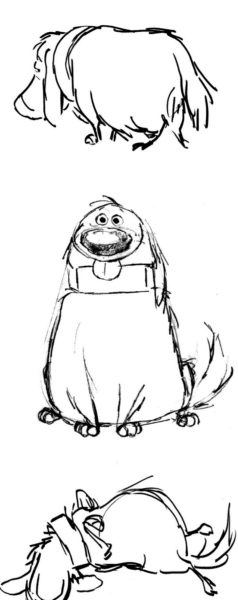

TONY FUCILE | pencil/digital | 2005

Old Muntz

"Muntz is a very old man in his nineties or early hundreds. Originally, we had a Fountain of Youth story where he was using the bird or its eggs to magically rejuvenate. So, at first he would appear to have barely aged from the 1930s—then transform to his true age, an ancient horror, someone who should have been dead but wasn't."

— Greg Dykstra, sculptor

RONNIE DEL CARMEN | digital | 2007

DANIEL LÓPEZ MUÑOZ | pencil/digital | 2007

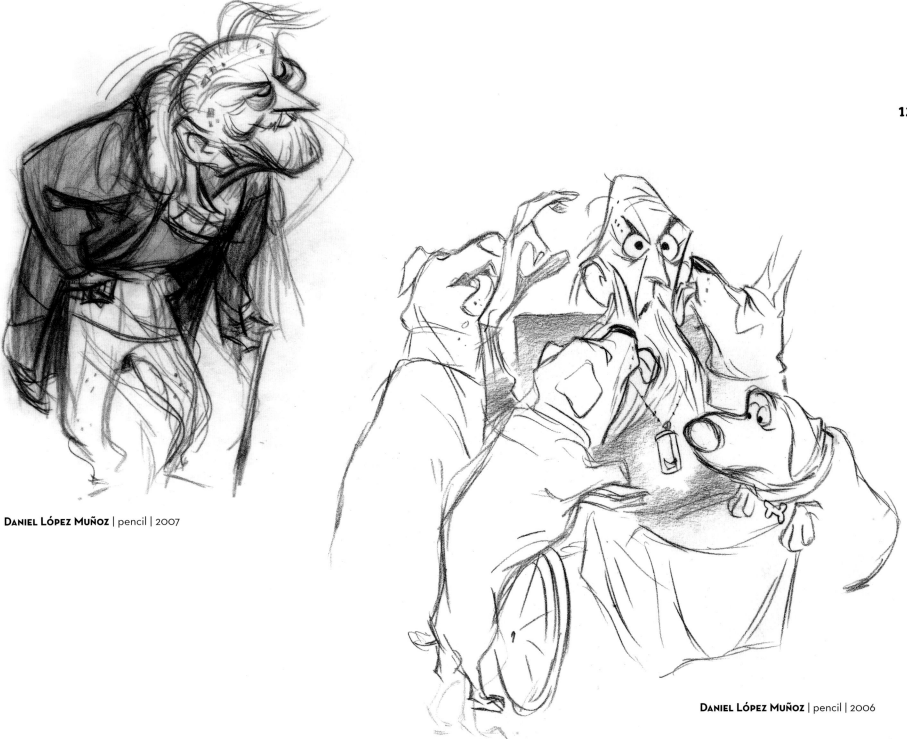

Daniel López Muñoz | pencil | 2007

Daniel López Muñoz | pencil | 2006

DANIEL LÓPEZ MUÑOZ | pencil | 2006

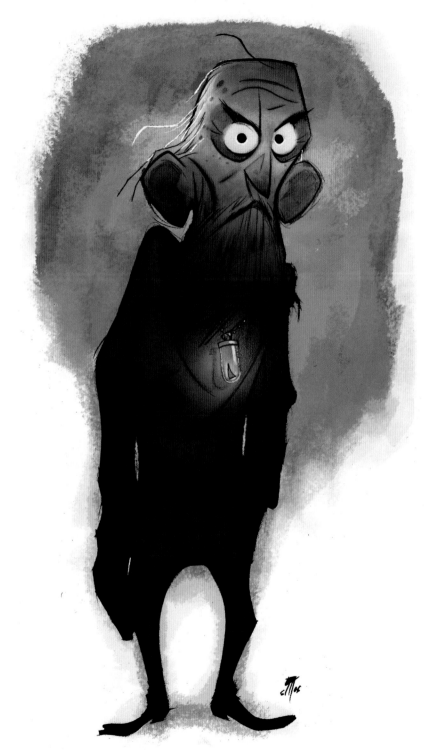

"Muntz has multiple diamond and triangle shapes going throughout his head and his hands. Compared to Carl's hand, which, if you look at it in overview is still very square, Muntz's hand has definite peaks and even the fingertips are triangular, they come to points."

— *Greg Dykstra, sculptor*

DANIEL LÓPEZ MUÑOZ | pencil/digital | 2006

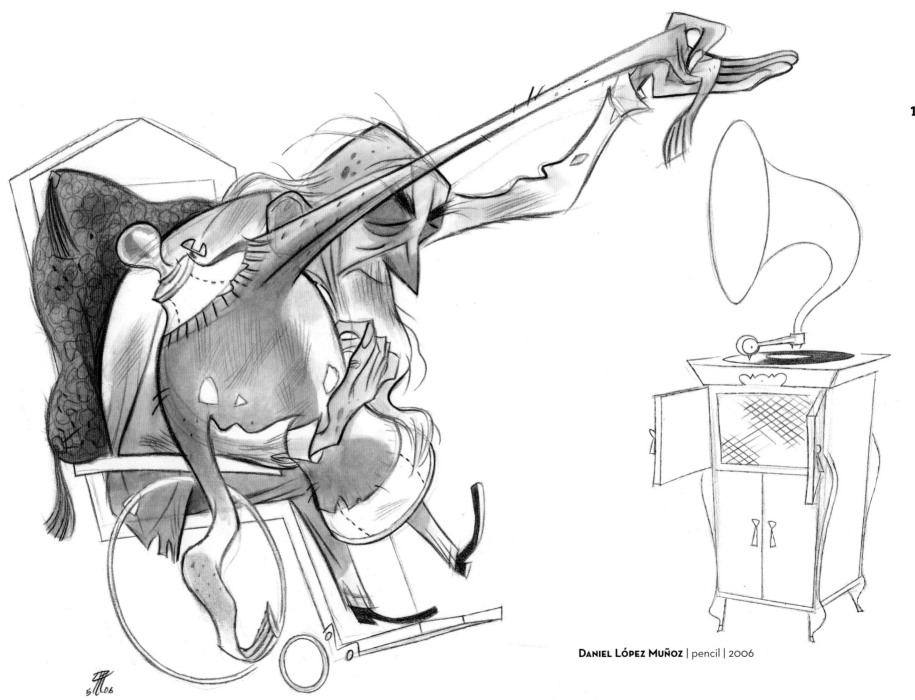

Daniel López Muñoz | pencil | 2006

Muntz's Lair

"We had Muntz's lair originally in a zeppelin hanger, which reflected his isolation and his being stuck in time, kind of like Carl. Now he's got his own cave, sort of a tomb that he's stuck in."

— Nat McLaughlin, designer

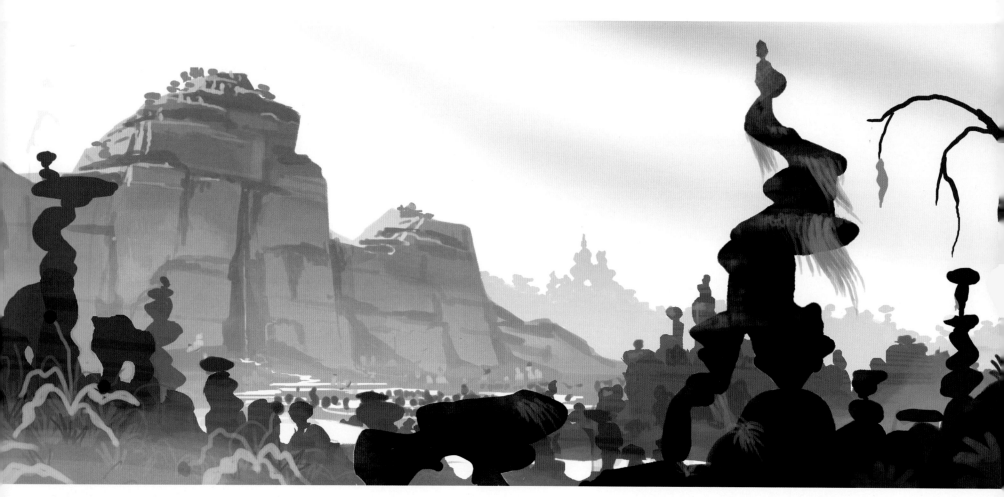

NAT McLAUGHLIN | digital | 2008

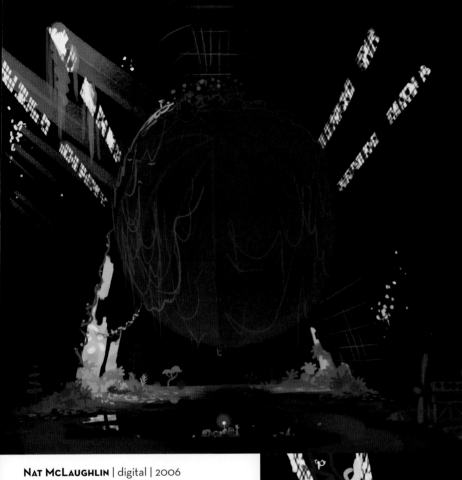

Nat McLaughlin | digital | 2006

Nat McLaughlin | digital | 2006

Nat McLaughlin | digital | 2006

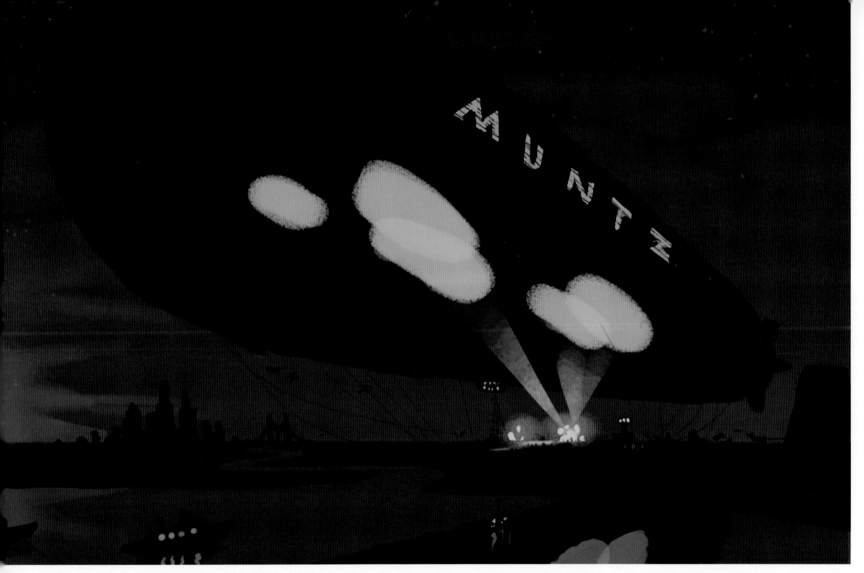

NAT MCLAUGHLIN | digital | 2006

"You can justify the grand scale, because in the 1930s Muntz gave tours of the dirigible and the whole county was excited about what he was doing. So it makes sense to have rooms that are a little more presentational as well as having utilitarian rooms. That's an interesting contrast."

— Harley Jessup, designer

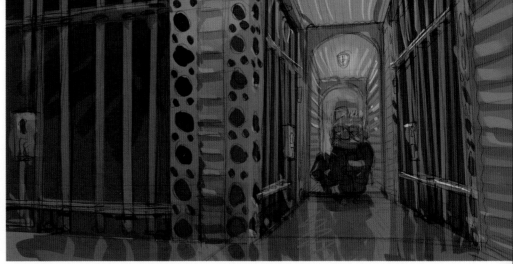

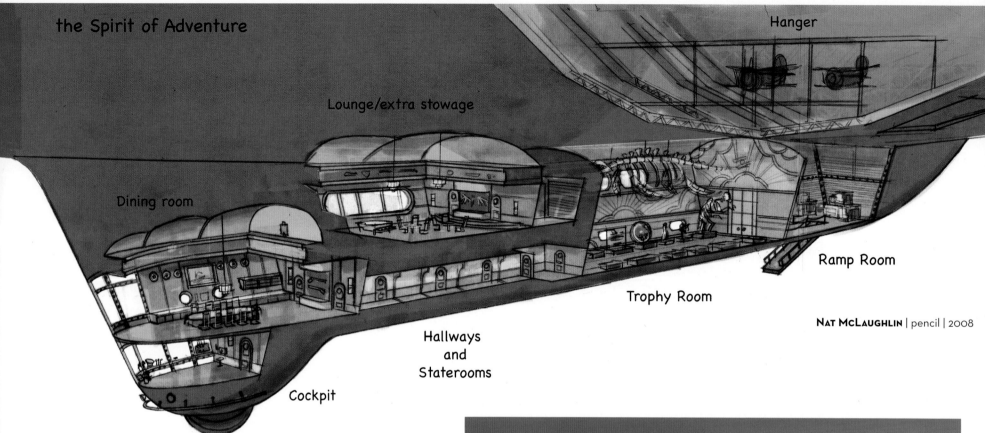

the Spirit of Adventure

Hanger

Lounge/extra stowage

Dining room

Ramp Room

Trophy Room

NAT McLAUGHLIN | pencil | 2008

Cockpit

Hallways
and
Staterooms

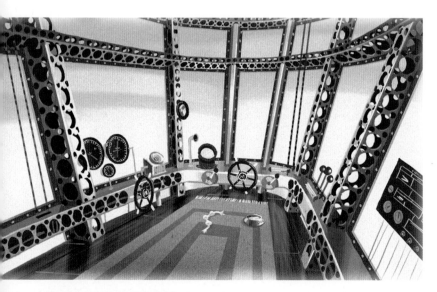

NAT McLAUGHLIN | digital | 2007

NAT McLAUGHLIN | digital | 2008

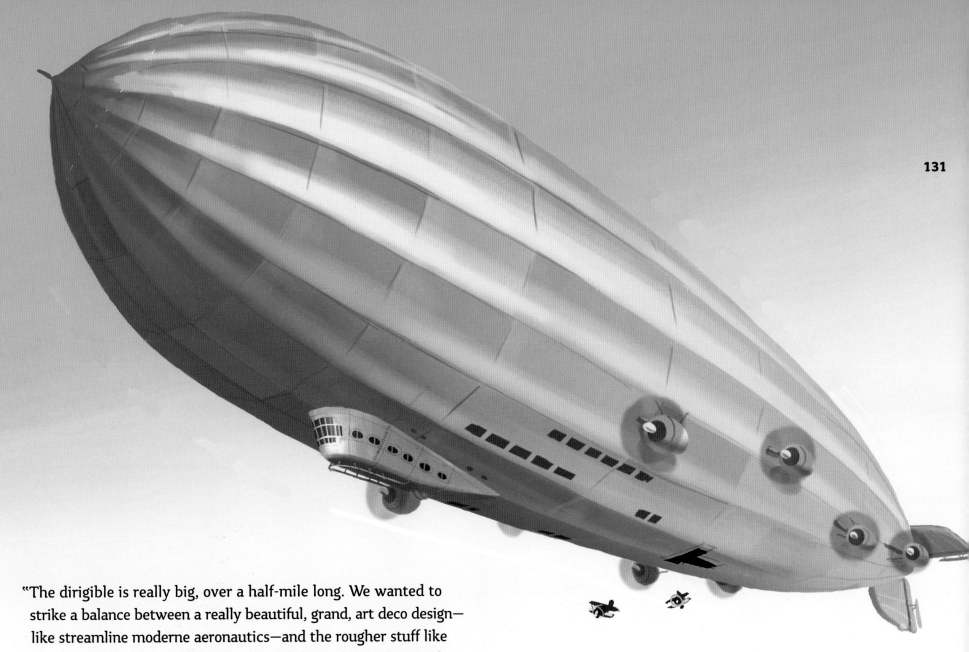

"The dirigible is really big, over a half-mile long. We wanted to strike a balance between a really beautiful, grand, art deco design—like streamline moderne aeronautics—and the rougher stuff like the airship structure itself. What's hard about that is the weight situation in a dirigible. We had a trophy room with an Easter Island head in there at one point and John Lasseter said, 'No. That would sink the ship.' Now we can see that they've cut holes in the structure beams so they could save weight."

— *Noah Klocek, production artist*

NAT MCLAUGHLIN | digital | 2007

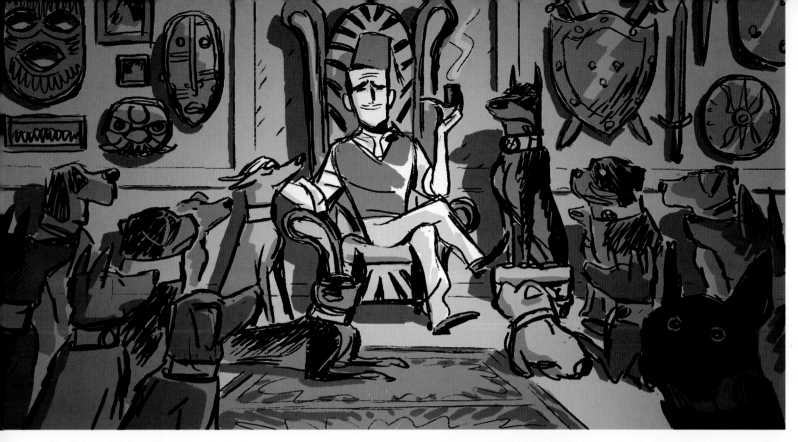

BILL PRESSING | digital | 2007

RONNIE DEL CARMEN | digital | 2007

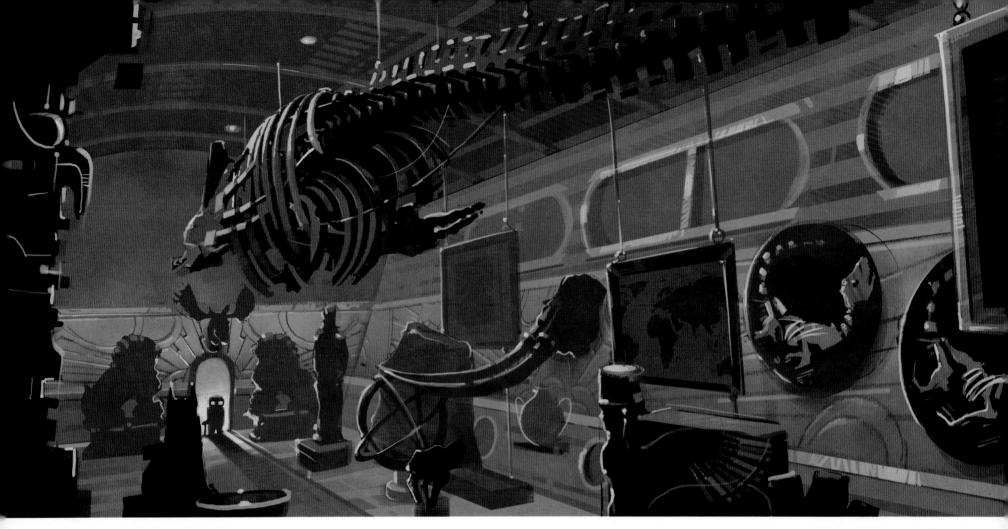

SANDEEP MENON | digital | 2007

"We dropped some of the heaviest stone pieces from Muntz's trophy room while mixing in some of the lighter anthropology items, African masks and those kinds of things that are treasures, but not so heavy. John's note was to make it as believable and authentic as we can, even in this caricatured world."

— Harley Jessup, designer

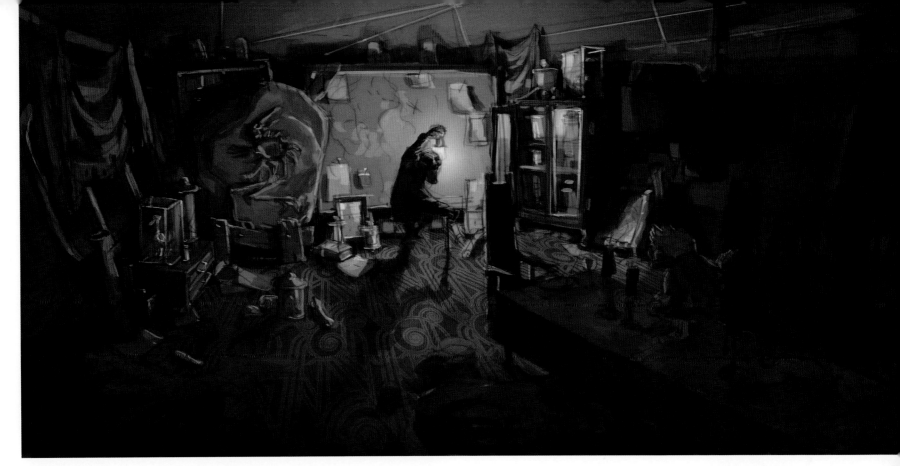

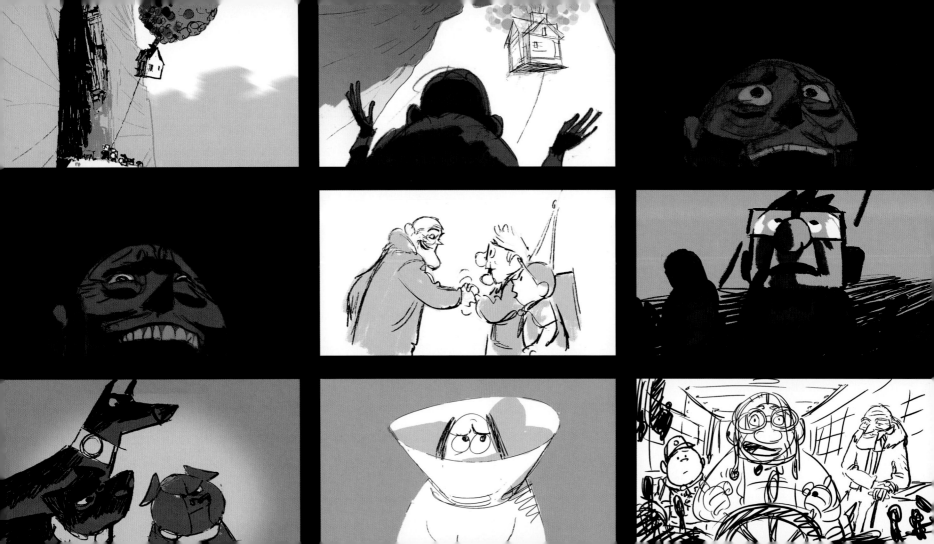

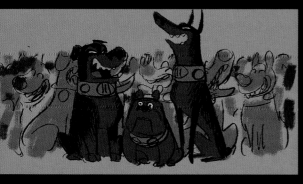

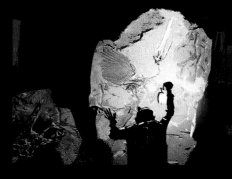

RONNIE DEL CARMEN, ENRICO CASAROSA, BILL PRESSING | digital | 2005–2008

The Alpha Pack

"Alpha, Beta, Gamma, their names say it all. They are strong, muscular, fast, athletic dogs—and then you have Dug, who obviously doesn't fit in the pack."

— Albert Lozano, designer

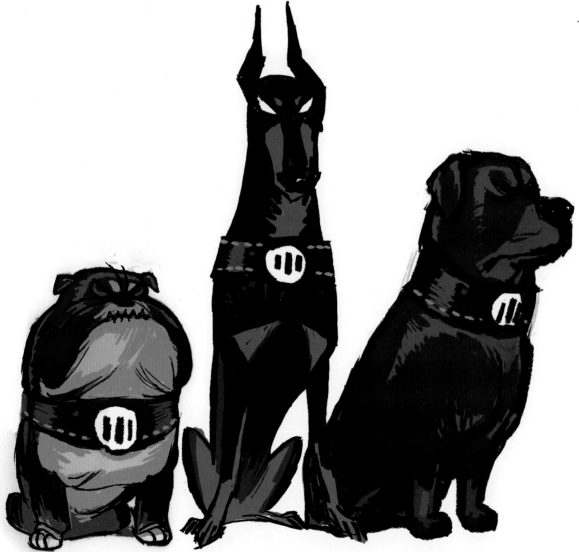

DANIEL LÓPEZ MUÑOZ | digital | 2007

RICKY NIERVA | pencil | 2007

"The Alpha Dogs were based on angles and bullet shapes, like heat-seeking missiles. These dogs are Muntz's weapons. An Alpha's movement imitates that of a rocket going through the jungle, so he needed to have that cutting-edge shape. He doesn't have to do too much to really hurt you."

— Daniel López Muñoz, designer

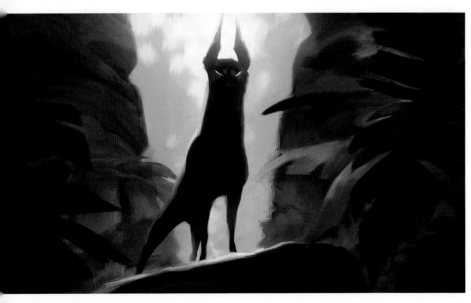

DANIEL LÓPEZ MUÑOZ | digital | 2008

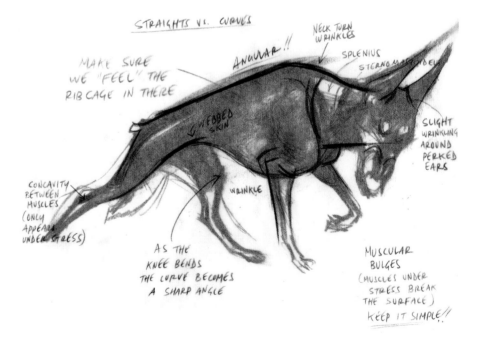

DANIEL LÓPEZ MUÑOZ | colored pencil | 2007

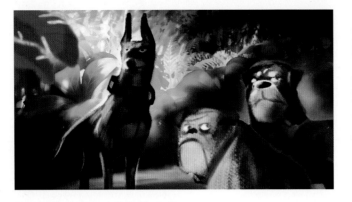

Ralph Eggleston | digital | 2008

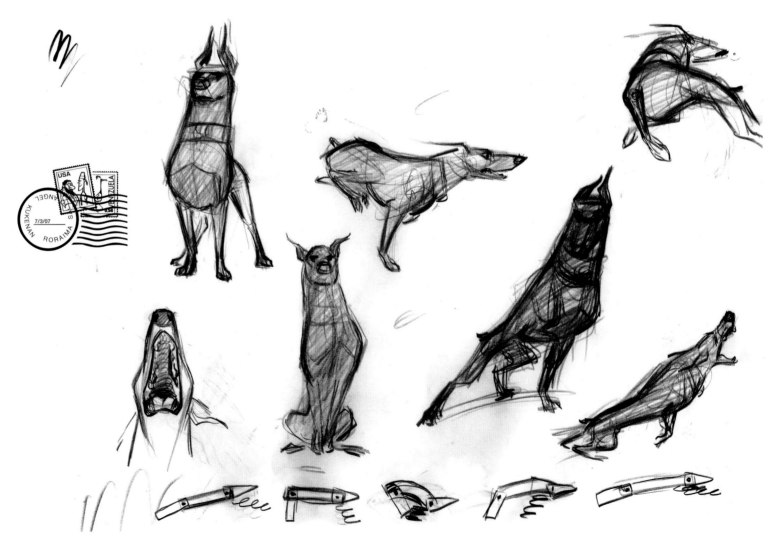

Bolhem Bouchiba | pencil | 2007

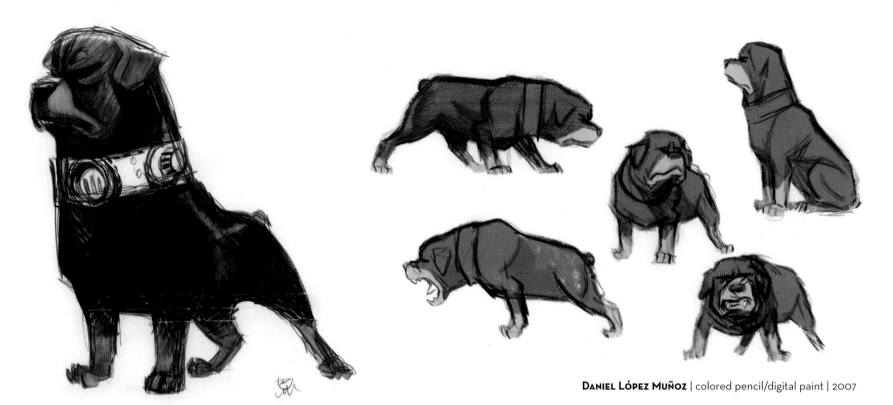

Daniel López Muñoz | colored pencil/marker | 2007

Daniel López Muñoz | colored pencil/digital paint | 2007

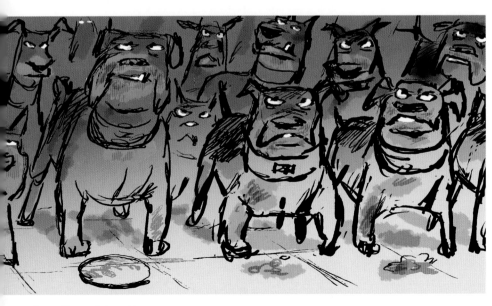

Jamie Baker | digital | 2006

DEFAULT

Daniel López Muñoz | pencil/digital | 2007

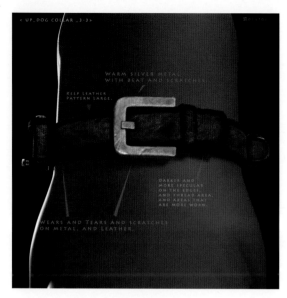

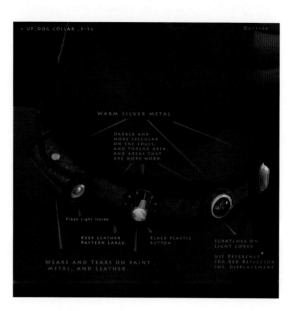

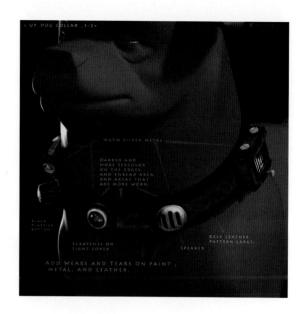

Jennifer Chang | digital | 2008

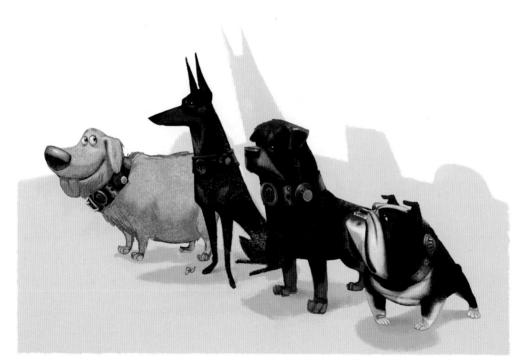

Daniel López Muñoz | digital | 2007

Daniel López Muñoz | digital | 2007

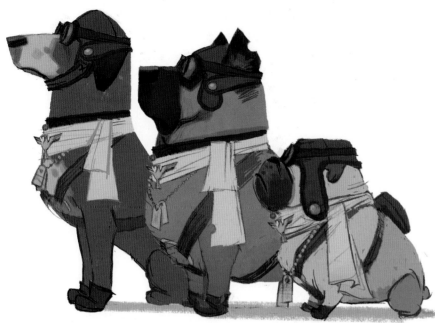

Daniel López Muñoz | pencil/digital | 2007

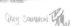

"I love comedy. I'm always looking for ways to bring humor into the movie. The dogs evolved pretty early on. As the emotional elements arose in the film, we had to keep them in check so they wouldn't be too silly."

— Bob Peterson,
codirector and writer

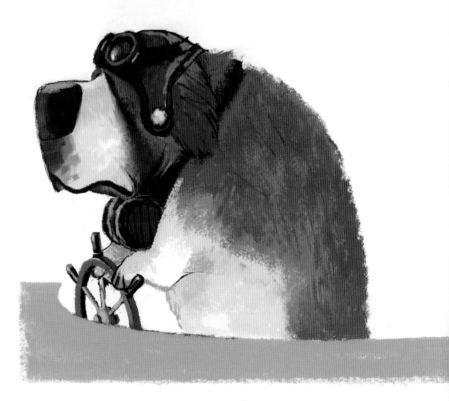

Daniel López Muñoz | pencil/digital | 2007

Josh Cooley | digital | 2008

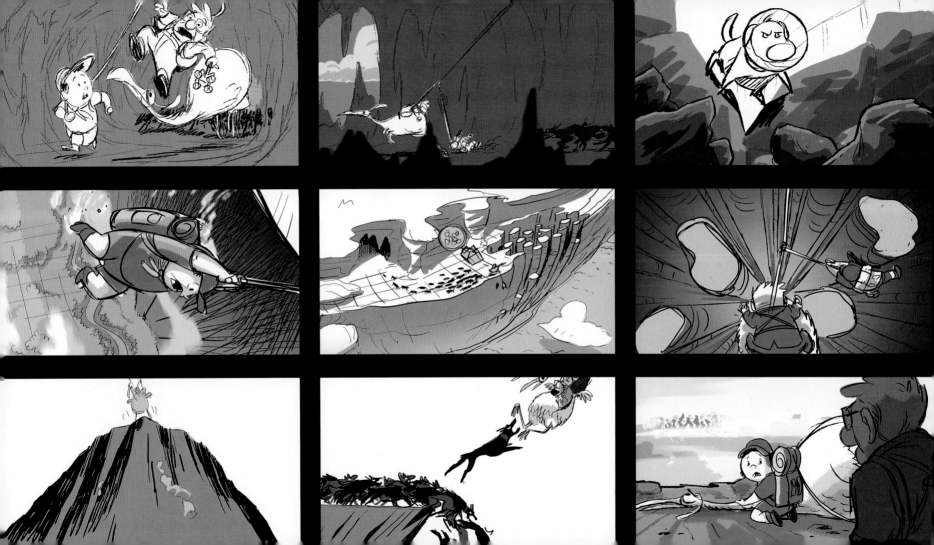

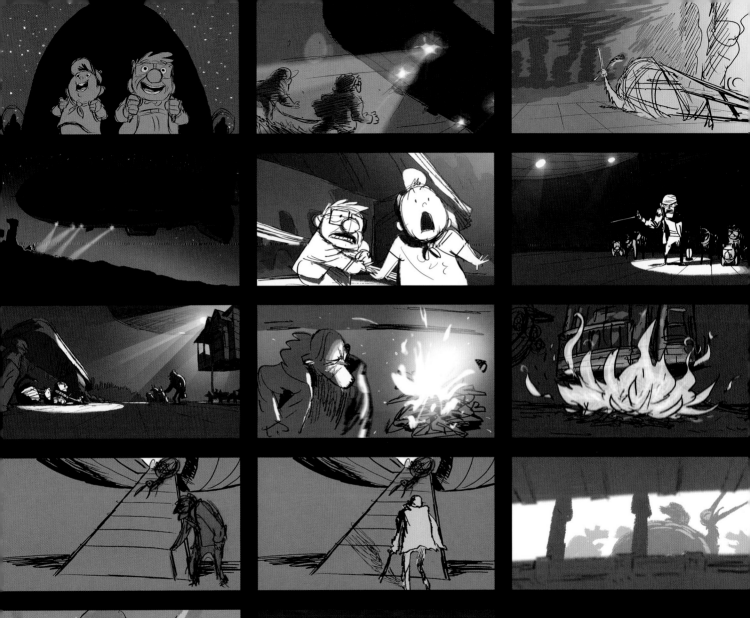

ENRICO CASAROSA, JOSH COOLEY, BILL PRESSING,
RONNIE DEL CARMEN | digital | 2008

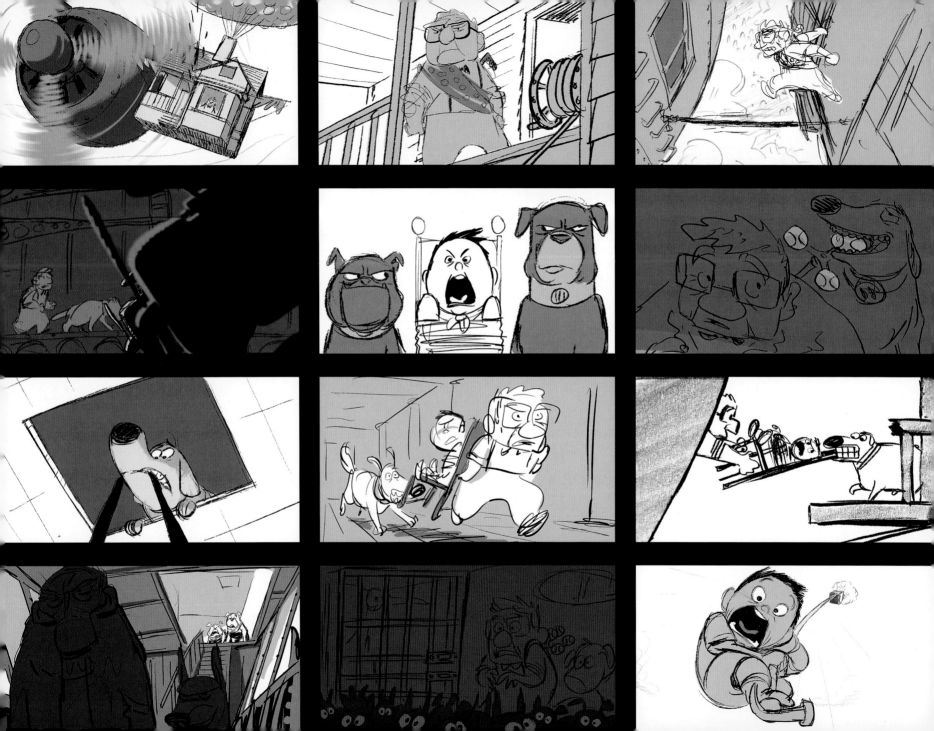

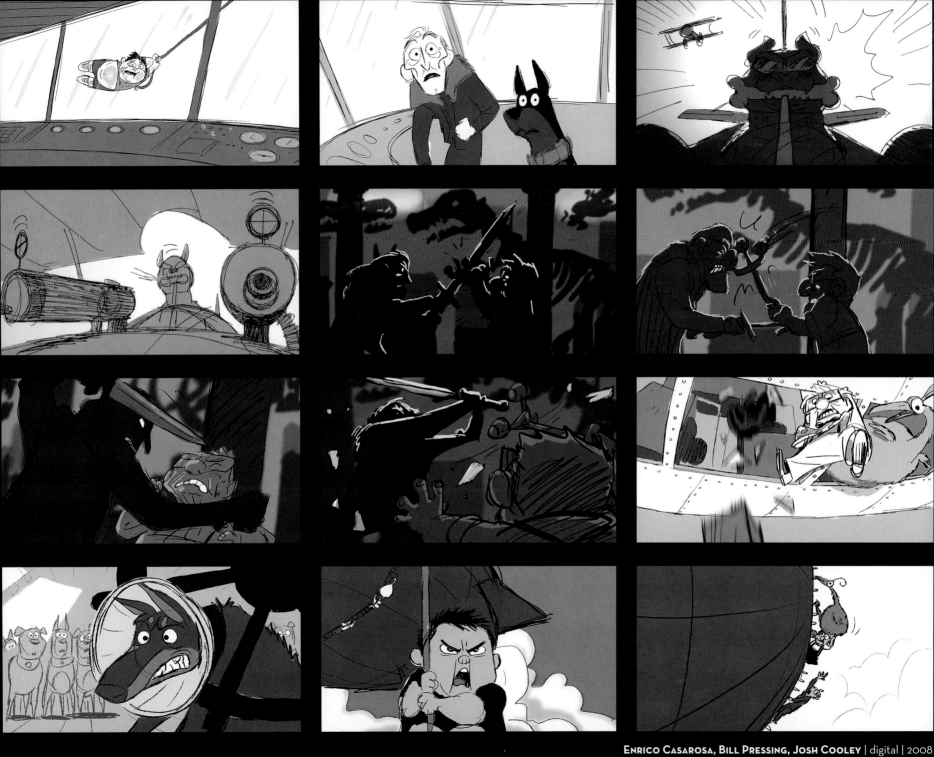

ENRICO CASAROSA, BILL PRESSING, JOSH COOLEY | digital | 2008

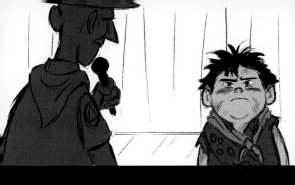

JUSTIN HUNT, JOSH COOLEY,
RONNIE DEL CARMEN | digital | 2008

LEWIS beCAUSE OF YouR HEROIC FEATS of COMPASSION — You DESERVE THE HIGHEST MERIT BADGE there is...

"Russell was initially named Lewis, but to avoid confusion with the character in *Meet the Robinsons*, we renamed him after a friend of my son's. As is turns out, 'Russell' seems to fit the character better anyway."
— Pete Docter, director

THE ELEANOR BADGE

"Joe Grant often talked about how in the old days at Disney they would bring in artists from outside the studio to work in the development group to kick off and inspire new projects. We often traded names of artists we admired, and one that came up often was Patrick McDonnell. Patrick's work has a wonderful charm, a great sense of character, and a deceptively simple complexity to it. He seemed a perfect fit for *UP*, and sure enough he came up with some great ideas."
— Pete Docter, director

PATRICK McDONNELL | watercolor | 2005

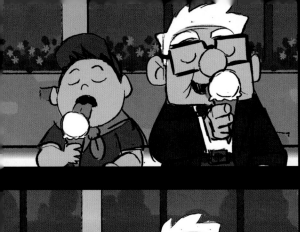

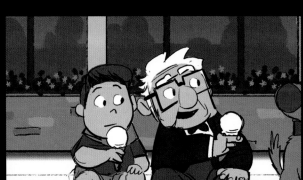
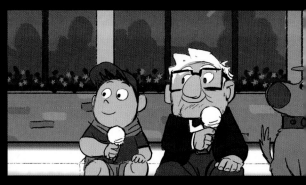
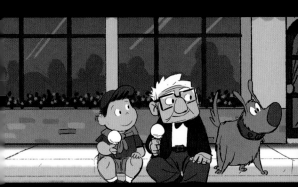
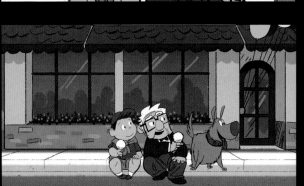
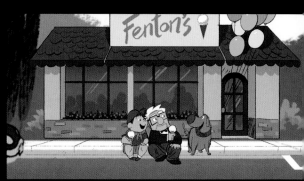
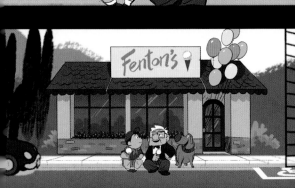

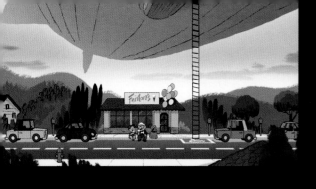
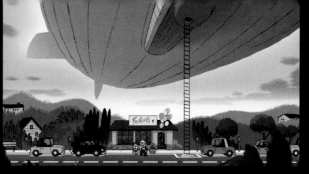
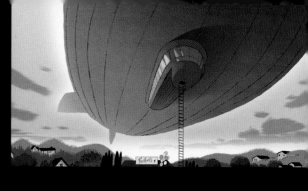

Epilogue

NO WAY TO GO BUT UP...

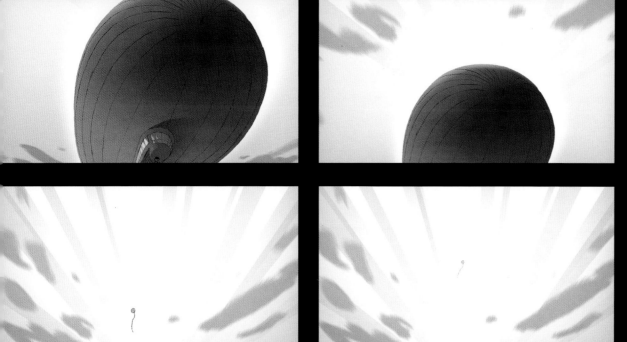

BILL DRESSING | digital | 2008

TONY FUCILE | pen | 2005

> "A good ending is vital to a picture,
> the single most important element,
> because it is what the audience takes
> with them out of the theater."
> — *Walt Disney*

152

TAKEN AS A WHOLE, PIXAR'S FILMS CAN be viewed as serialized chapters in a single life: from sibling rivalry, early attachment (*Toy Story*), and socialization (*A Bug's Life*), to maturation (*Monsters, Inc.*), separation, and parenthood (*Toy Story 2, Finding Nemo*); from protecting the nuclear family (*The Incredibles*), shifting out of the fast lane (*Cars*), and rekindling passion (*Ratatouille*), to planning for future generations (*WALL•E*), and, finally, accepting death (*Up*).

Is this progression intentional?

"It's nothing that we're setting out to do," observes Bob Peterson. "But we're all aging. We all have families. And you write what you know. As older filmmakers, we are examining themes of life that might be different than when you're thirty or twenty."

An animated family film may seem an odd vehicle for allegories of death, acceptance, and healing. But storytellers have always used fantasy archetypes—witches, dragons, and talking beasts—to symbolize the challenges of life that we must overcome at any age.

Walt Disney himself made movies that addressed the cycle of life, such as *Bambi, Old Yeller,* and *The Three Lives of Thomasina*. These stories recognized death as part of our daily struggle, portraying relatable protagonists who move beyond emotional crises to find new and wonderful experiences.

"I didn't treat my youngsters like frail flowers, and I think no parent should," explained Disney of his dramatic choices. "Children are people, and

they should have to reach to learn about things, to understand things, just as adults have to reach if they want to grow in mental stature. Life is composed of lights and shadows, and we would be untruthful, insincere, and saccharine if we tried to pretend there were no shadows."

"One of the things that I've been so inspired by in the films of Walt Disney is the messages that he puts across," says John Lasseter. "You come away learning something, because that's what gives these films so much heart and feeling, and you think about them long after the credits stop rolling."

"We were all touched by the early fantasy films like *Peter Pan* because the filmmakers were really optimistic about the future and the world they lived in," says Daniel López Muñoz. "Because this was

such a heavy subject, it was important for us to retain that quality, to take the ending to a place of optimism, to show that there was still hope even in the face of death."

During the long development and production of *Up*, the film crew endured many personal losses. Parents and friends passed on; loved ones became ill. Each of the artists invested that emotion back into their film.

"Somehow, this film is a way to honor our lives and all the members of our families who will come and go," expresses Ronnie del Carmen. "My dad was in an old folks' home and passed away during the time that we were making the story reels. I was especially connected to the story, because my father and I were not able to talk as much as we wanted to. He struggled to speak and I had to try to connect to him. And here I was making a movie about an old man at the end of his life. This was a way for me to work that through, but it was hard for me. I tended to draw him in the reels."

One loss in particular affected the entire Pixar family. Much-loved story man Joe Ranft passed away during the development of *Up*. But Peterson feels that Ranft's spirit lives on in the heart of the picture: "That loss definitely magnified the theme for us and helped bring it into focus. Joe was an example of someone who taught us a lot, and we keep him alive everyday with how we make these movies."

"Joe's stamp is on everything we do here. He was such a vital ingredient and I always think about that. The day he died was the day the earth shifted for me, and I think it did for everyone here," adds Jonas Rivera.

For everyone who knew him, Ranft was a gentle force of life and laughter who possessed a keen, intuitive sense of story. He helped to craft imaginative screen stories that were among the best of our generation: the *Toy Story* films, *The Little Mermaid*, *Beauty and the Beast*, *The Nightmare Before Christmas*, *The Brave Little Toaster*, *A Bug's Life*, *Monsters, Inc.*, *The Corpse Bride*, *Cars*, and so many more. His premature death was a great loss to animators and audiences alike.

Ranft's passing caused Pixar's youthful staff to pause and reflect on their own mortality. "Joe had seen the film early on," says Docter. "When he died, that totally shook the whole studio. It made

RICKY NIERVA | pencil/digital paint | 2004

me wonder, 'Why am I coming to work? How does making cartoons really matter?' I guess that's a normal part of loss. It forces you to reexamine your life. As soon as Joe died, I had all these questions that I desperately needed to ask him, but I couldn't anymore. Up to that time I thought, 'Oh, well, I'll ask later.' But there is no later. By having loss in the story, we hope to help people realize and appreciate what they have right now."

Ranft had often urged his teammates to 'trust the process' of change. The story of *Up* perpetuates that request. "We must learn from those we knew and, when we lose them, move past that, having gained their knowledge and wisdom," shares Peterson. "The person whose hand you are holding is the most important thing. Don't place faith in tomorrow but place it on the now. Place that faith on making sure the people around you know that they are loved."

Another Joe also figured prominently around the studio. "I was lucky enough to hang around with Pete's mentor, Joe Grant," recalls Rivera. "Pete would go down to Glendale and have lunch or dinner with him, and I'd tag along. Sitting down

and having a cup of coffee with Joe Grant was like being let in on this unbelievable life. His stories were absolutely amazing."

Grant served as head of Disney's story department in the 1940s, contributing to the creation of many golden-age classics, including *Dumbo*, *Fantasia*, and *Lady and the Tramp*. Returning to the studio in his later years, Grant passed his knack for visual humor and caricature on to a new generation of storytellers.

"Joe Grant was probably more like Ellie than Carl," Docter reflects, "because he was a guy who, up

until his dying day, was continually experimenting with new techniques, going to see all the latest films, looking at new ways of telling stories."

"One thing that he always asked us was, 'What are you giving the audience to take home? What's the audience going to remember from this film? Not only today, but tomorrow, the next year, their entire life?' Usually, it's those great emotional moments that lodge in your memory," recalls Docter.

Rivera hopes some of that wisdom can be passed along to younger people. "This is a movie about memories and how to honor the past. At the same

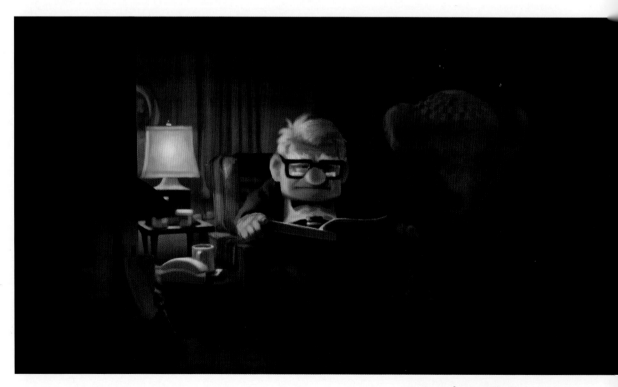

DANIEL LÓPEZ MUÑOZ | digital | 2008

"The journey of a thousand miles begins with one step."
— Lao Tzu, Tao-te Ching

time, it's a movie about moving forward and living in the present. From the sidelines, I can't help but think that there's a lot of Joe Grant in this film—that Pete, in a way, has made a love letter to our grandparents' generation."

The filmmakers aim to bridge the generation gap by helping the audience identify with the bond between Carl and Russell. "One of my hopes for this film is that children will look at their grandparents differently after seeing this movie," says production manager Mark Nielsen. "When you are young, you don't really think about their stories, what they've been through, what shaped them."

Docter's own casual observations of 'the greatest generation' provided inspiration for the reflective themes of *Up*. "When you see these eighty-five-year-old guys sitting on a park bench, you have no idea what kind of rich life they lived. Most of us, especially here in America, think, 'Well, what do they know? They're not relevant anymore. That time has gone,' and we just put them up on a

shelf somewhere. But I think there is so much more to be learned from their experience."

"If you actually sat down and talked to that person, they'd have some great story to tell," suggests Peterson. "Some saga, some adventure from World War II or the Depression or another big event they've been through. You never know until you ask."

Pete Docter has been lucky enough to know many of his childhood heroes. He pauses to consider Frank Thomas and Ollie Johnston, the last of the "Nine Old Men," who defined the art of animation from Mickey Mouse to *The Rescuers*.

"I remember [meeting] Frank and Ollie, these old guys who had drawn all that great animation I knew and I loved. I looked at their timeworn hands—and I realized that these were the hands that had made all those amazing films. Then I began to look at other elderly people and wonder, 'What's his story?'"

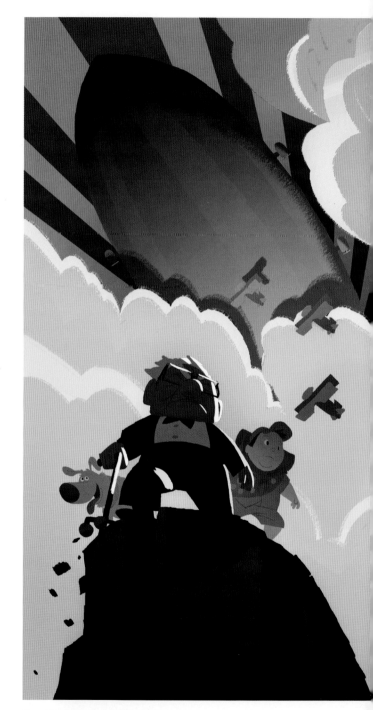

BILL PRESSING | digital | 2007

BIBLIOGRAPHY

Anitei, Stefan. "This Is The Lost World: Roraima." Softpedia.com. http://news.softpedia.com/news/This-is-The-Lost-World-Roraima-78833.shtml.

Baum, Lyman Frank. *The Wonderful Wizard of Oz*. Chicago: George M. Hill Company, 1900.

——. *The Lost Princess of Oz*. Chicago: Reilly and Britton, 1917.

Davis, Marc. "Disney Legends: Mary Blair (Animation and Imagineering)." Disney.com. http://legends.disney.go.com/legends/detail?key=Mary+Blair.

Disney, Walt. "Walt Disney Quotes." Disneydreamer.com. http://www.disneydreamer.com/walt/quotes.htm.

——. "From the Wisdom of Walt Disney." *Wisdom Magazine*, December 1959.

Docter, Pete, Bob Peterson, and Jonas Rivera. "*Up* Presentation." Pixar Animation Studios press conference. New York, May 29, 2008.

Docter, Pete. "*Up* Presentation." Comic Con International. San Diego, July 26, 2008.

Doyle, Arthur Conan. *The Lost World*. London: Hodder & Stoughton, 1912.

Eliot, Thomas Stearns. "Little Gidding." *Four Quartets*. New York: Harcourt Brace, 1943.

Goldschmidt, Rick. *Rudolph, the Red-Nosed Reindeer: The Making of the Rankin/Bass Holiday Classic*. Studio City, CA: Miser Bros. Press, 2001.

Henson, Jim. *It's Not Easy Being Green: And Other Things to Consider*. New York: Hyperion Books, 1995.

Harmetz, Aljean. *The Making of the Wizard of Oz*. New York: Alfred A Knopf, 1977.

Harris, Judy. "Muppetmaster; An Interview with Jim Henson." (Interview September 21, 1982). Muppetcentral.com, 1998. http://www.muppetcentral.com/articles/interviews/jim1.shtml.

——. "Of Precious Pigs, Singing Cabbages, and a Little Green Frog Named Kermit: The Story of Jim Henson and the Muppets." *Cinefantastique*, April/May 1983, pp. 24–31.

Hauser, Tim. Interviews with Ronnie del Carmen, Enrico Casarosa, Scott Clark, Elie Docter, Pete Docter, Greg Dykstra, Tony Fucile, John Halstead, Bryn Imagire, Thomas Jordan, Harley Jessup, Noah Klocek, Shawn Krause, Patrick Lin, Daniel López Muñoz, Albert Lozano, Steve May, Nathaniel McLaughlin, Dave Mullins, Mark Nielsen, Ricky Nierva, Bob Peterson, Jonas Rivera, Don Shank, and Mike Ventorini (for *The Art of Up*. Chronicle Books, 2009). Rec. May 15–August 1, 2008.

——. Interviews with Pete Docter, Bob Peterson, Jonas Rivera (for *The Pixar Treasures*, Disney Editions, 2009). Rec. March 5–7, 2008.

——. Interviews with Pete Docter and John Lasseter (for *The Art of WALL*E*. Chronicle Books, 2008). Rec. March 29–April 20, 2007.

Lao Tzu. *The Way of Lao Tzu (Tao-te Ching)*. China; 4th Century B.C., Tr. Wing-tsit Chan. Upper Saddle River: Prentice Hall, 1963.

Lasseter, John. "John Lasseter on Walt Disney." *The Walt Disney Family Museum*. (Excerpted from interviews for *Walt: The Man Behind the Myth*, dir. Jean-Pierre Isbouts, Walt Disney Home Entertainment, 2001). Disney.com.

Melville, Herman. *White-Jacket*. London: Richard Bentley, 1850.

Nakashima, Ryan. "Disney Says Pixar Movies Will Be Released in 3-D." Associated Press. April 8, 2008.

Rasky, Frank. "80 Million a Year from Fantasy." *Star Weekly*, November 14, 1964, pp. 8–11.

Solomon, Charles. "Cartoons Have Their John Henry Moment." The *New York Times*, January 15, 2006.

Thomas, Frank, and Oliver Johnston. *Disney Animation: The Illusion of Life*. New York: Abbeville Press, 1981.

Walt Disney Productions. *Walt Disney's Surprise Package*. New York: Simon and Schuster, 1944.

"Our goal is not for you to notice the artwork or to notice how well that car was designed or how well that doorway fits with that character. Our job is to make it seamless, so you get immersed in the story. Hopefully, you don't even notice the art and you just fall in love with the story and characters."

— *Noah Klocek, sketch artist*

RICKY NIERVA | production design roadmap | 2006

ACKNOWLEDGMENTS

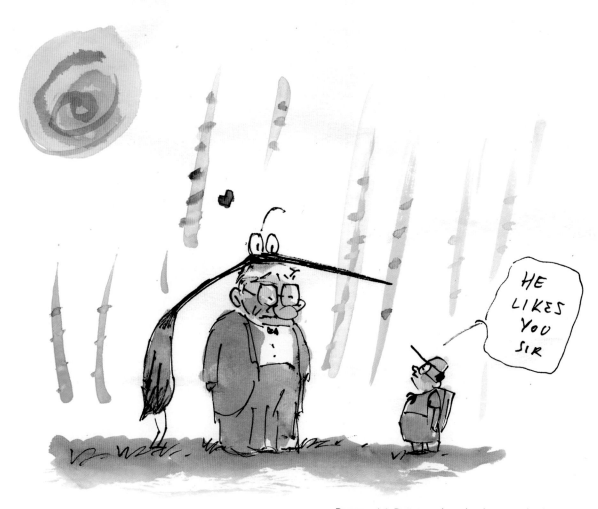

PATRICK McDONNELL | marker/water color | 2005

THE AUTHOR WOULD LIKE TO THANK PIXAR publishing manager Kathleen Chanover for her efforts, talent, and kindness. Thanks also to Pixar's Erik Langley, Aidan Cleeland, Stella Koh, Victoria Manley, and Veronica Watson for their help and support.

The text owes its "simplexity" to Ronnie del Carmen, Enrico Casarosa, Scott Clark, Elie Docter, Pete Docter, Greg Dykstra, Tony Fucile, John Halstead, Bryn Imagire, Thomas Jordan, Harley Jessup, Noah Klocek, Shawn Krause, Patrick Lin, Daniel López Muñoz, Albert Lozano, Steve May, Nathaniel McLaughlin, Dave Mullins, Mark Nielsen, Ricky Nierva, Bob Peterson, Jonas Rivera, Don Shank, and Mike Ventorini. Thanks also to Pete Docter, Bob Peterson, Jonas Rivera, Ricky Nierva, John Lasseter, and Ed Catmull for allowing me to be part of this process.

I extremely grateful for the pruning and polish of editors Sarah Malarkey, Matt Robinson, Rebecca Cohen, and Karen Stein at Chronicle Books. Thanks also to Chronicle's Jennifer Kong, Deirdre Merrill, Will Swanson, and April Whitney for their timely assistance.

Personal thanks go to Brandon Maxwell, without whose support this process would not have been possible. I extend thanks also to Ralph Eggleston and Alex Rannie for their encouragement.

And last, I'd like to offer a thought for those who have gone before us, including my mother, Virginia Mae Hauser, who passed away just prior to the writing of this book. Her spirit lives on in love and laughter.

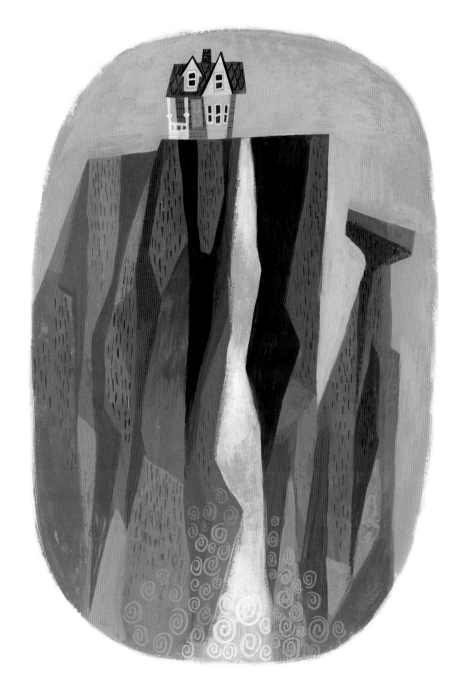

LOU ROMANO | gouache | 2008

PETE DOCTER | red pen on napkin | 2008

"Every director is a mirror of every experience that they've had, or every filmmaker that has inspired them. In the end, this is very much a Pete Docter film because of the emotional content."

— Daniel López Muñoz, designer

1997
CLINTON

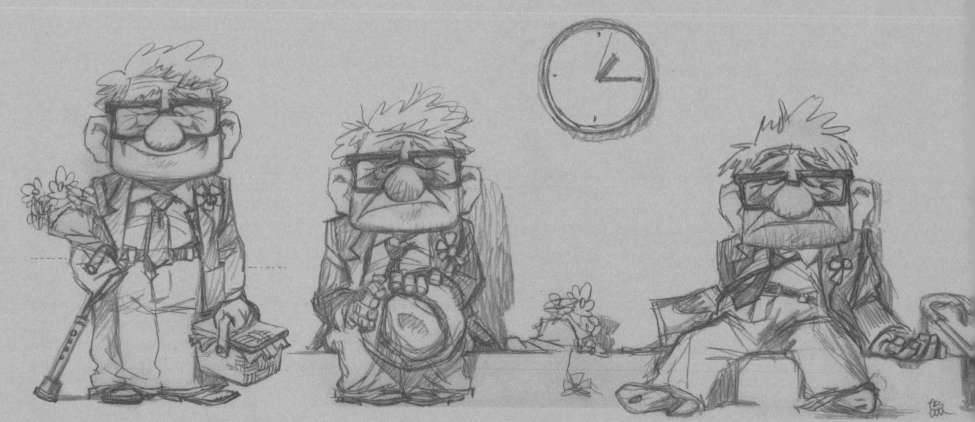

THE DAY OF ELLIE'S BREAKDOWN

70